IRELAND'S
BEAUTIFUL
NORTH

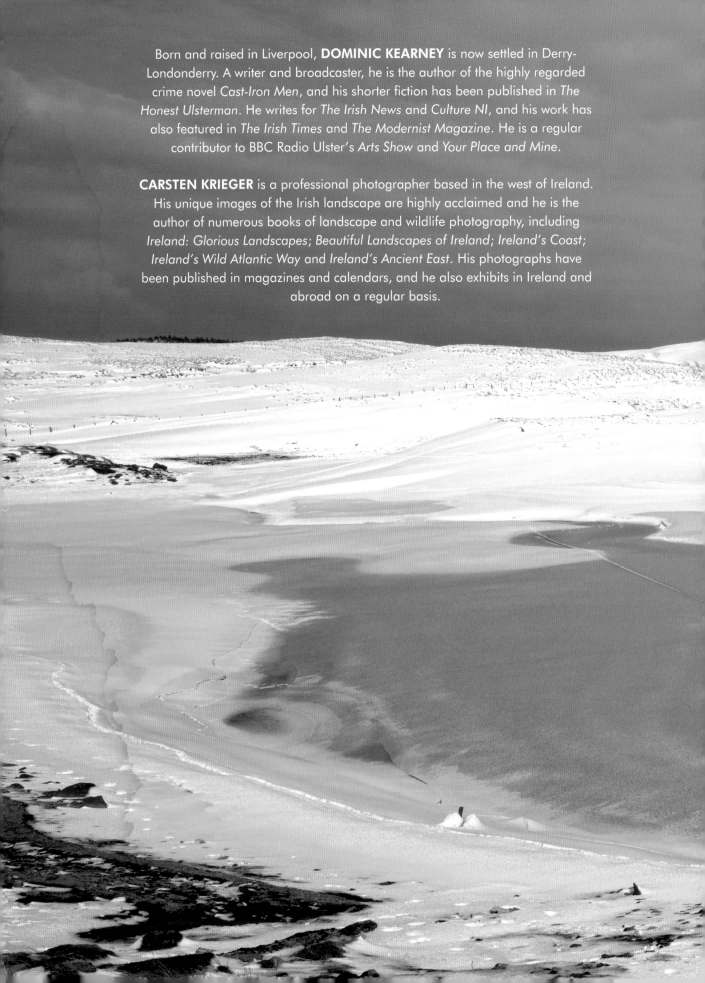

Born and raised in Liverpool, **DOMINIC KEARNEY** is now settled in Derry-Londonderry. A writer and broadcaster, he is the author of the highly regarded crime novel *Cast-Iron Men*, and his shorter fiction has been published in *The Honest Ulsterman*. He writes for *The Irish News* and *Culture NI*, and his work has also featured in *The Irish Times* and *The Modernist Magazine*. He is a regular contributor to BBC Radio Ulster's *Arts Show* and *Your Place and Mine*.

CARSTEN KRIEGER is a professional photographer based in the west of Ireland. His unique images of the Irish landscape are highly acclaimed and he is the author of numerous books of landscape and wildlife photography, including *Ireland: Glorious Landscapes; Beautiful Landscapes of Ireland; Ireland's Coast; Ireland's Wild Atlantic Way* and *Ireland's Ancient East*. His photographs have been published in magazines and calendars, and he also exhibits in Ireland and abroad on a regular basis.

IRELAND'S
BEAUTIFUL
NORTH

Dominic Kearney

with photographs by
Carsten Krieger

THE O'BRIEN PRESS
DUBLIN

First published 2017 by The O'Brien Press Ltd.
12 Terenure Road East, Rathgar, Dublin 6, D06 HD27, Ireland.
Tel: +353 1 4923333; Fax: +353 1 4922777
E-mail: books@obrien.ie; Website: www.obrien.ie
Reprinted 2018.
The O'Brien Press is a member of Publishing Ireland.

ISBN: 978-1-84717-835-0

Copyright for text © Dominic Kearney 2017
Copyright for majority of photographs © Carsten Krieger 2017
Copyright for map © Fiachra McCarthy 2017
Copyright for typesetting, editing, layout and design © The O'Brien Press Ltd

All rights reserved. No part of this publication may be
reproduced or utilised in any form or by any means,
electronic or mechanical, including photocopying, recording
or in any information storage and retrieval system,
without permission in writing from the publisher.

10 9 8 7 6 5 4 3 2
23 22 21 20 19 18

Page 1: Sunset, Ballyhiernan Bay, County Donegal.

Pages 2-3: Loughareema, County Antrim.

Pages 4-5: Ards Forest Park, County Donegal.

Pages 6-7: Whitepark Bay and Portbradden, County Antrim.

Printed and bound in Drukarnia Skleniarz, Poland.
The paper in this book is produced using pulp from managed forests.

Published in

DUBLIN
UNESCO
City of Literature

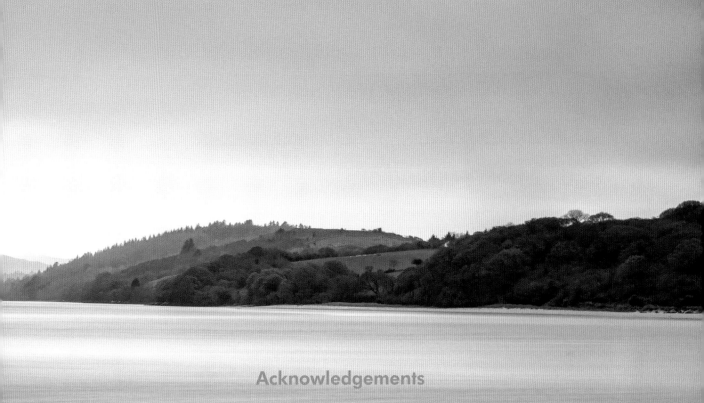

Acknowledgements

With thanks to Dr Tim Campbell, Director of the Saint Patrick Centre, Downpatrick, for his time, knowledge, and expertise. Thanks also to Fionnuala McCullagh for her suggestions and advice.

The Publisher would like to thank Naomi Waite, Director of Marketing at Tourism Northern Ireland, MaryJo McCanny, Director of Visitor Servicing, and Fiona Ure, Communications Executive, at Visit Belfast, and Margaret O'Reilly, Head of Corporate & Industry Communications of Tourism Ireland.

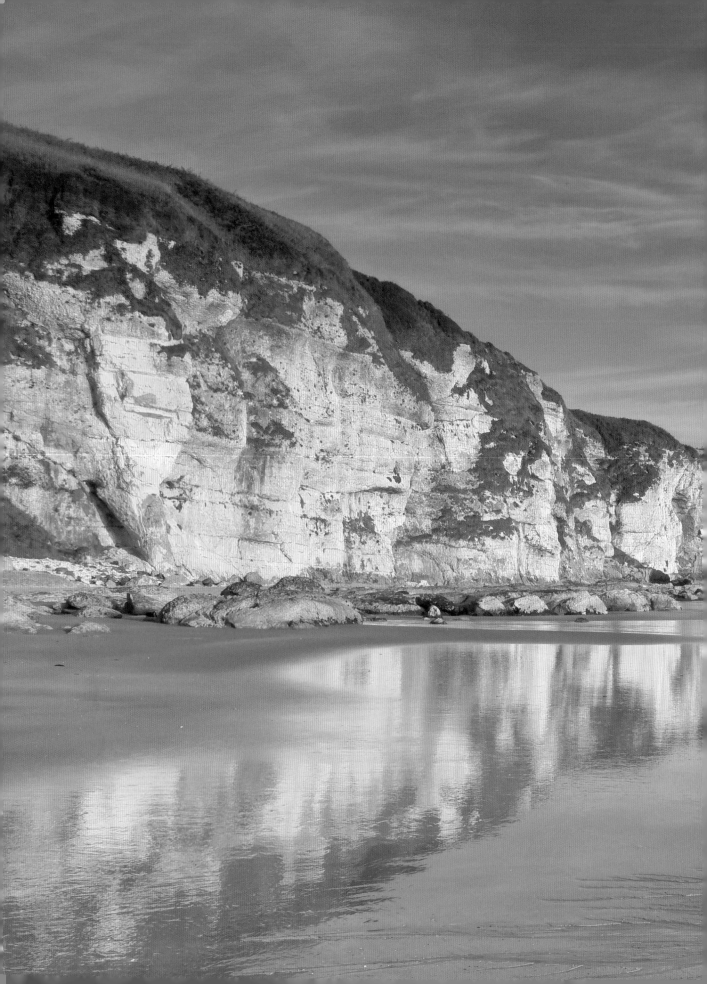

Photograph credits

Copyright for photographs:
Fiachra McCarthy, pp8–9 map;
Chris Hill @ Scenicireland.com, p30 St George's Market,
p56 Derry-Londonderry fireworks, p90 Clones round tower,
& p91 Dromore River;
Paul Lindsay @ Scenicireland.com,
p29 Belfast City Hall, p30 St Anne's, p32 Botanic
Gardens, & p55 St Columb's;
p83 (top) Image courtesy of Marble Arch Caves Geopark,
reproduced with permission.

*The author and publisher have endeavoured to establish the origin
of all images used. If any involuntary infringement of copyright
has occurred, sincere apologies are offered and the owners are
requested to contact the publishers.*

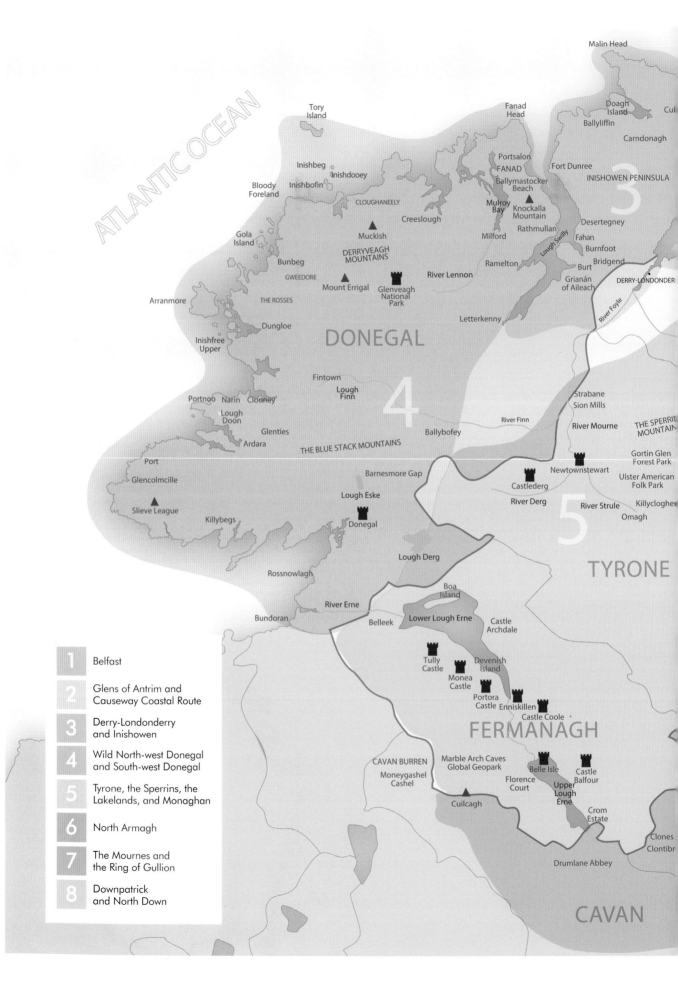

ATLANTIC OCEAN

Malin Head

Tory Island

Inishbeg
Inishdooey

Inishbofin

Bloody
Foreland

Gola
Island

Arranmore

Dungloe

Inishfree
Upper

Portnoo Narin Clooney

Lough
Doon

Glenties

Ardara

Bunbeg

GWEEDORE

THE ROSSES

CLOUGHANEELY

Creeslough

Muckish

DERRYVEAGH
MOUNTAINS

Mount Errigal

Glenveagh
National
Park

River Lennon

Fanad
Head

Doagh
Island

Cul

Ballyliffin

Carndonagh

Portsalon
FANAD

Fort Dunree

INISHOWEN PENINSULA

3

Ballymastocker
Beach

Mulroy
Bay

Knockalla
Mountain

Milford

Rathmullan

Ramelton

Desertegney

Fahan

Burnfoot

Bridgend

Burt

Grianán
of Aileach

DERRY-LONDONDER

Letterkenny

River Foyle

Fintown

Lough
Finn

4

DONEGAL

Strabane

Sion Mills

River Finn

River Mourne

THE SPERRI
MOUNTAIN

Ballybofey

THE BLUE STACK MOUNTAINS

Gortin Glen
Forest Park

Newtownstewart

Ulster American
Folk Park

Castlederg

River Derg

River Strule

Killyclogher

Omagh

Port

Glencolmcille

Slieve League

Killybegs

Barnesmore Gap

Lough Eske

Donegal

Rossnowlagh

Lough Derg

5

TYRONE

Bundoran

River Erne

Belleek

Boa
Island

Lower Lough Erne

Castle
Archdale

Tully
Castle

Monea
Castle

Devenish
Island

Portora
Castle

Enniskillen

Castle Coole

FERMANAGH

CAVAN BURREN

Moneygashel
Cashel

Marble Arch Caves
Global Geopark

Florence
Court

Belle Isle

Upper
Lough
Erne

Castle
Balfour

Cuilcagh

Crom
Estate

Drumlane Abbey

Clones

Clontibr

CAVAN

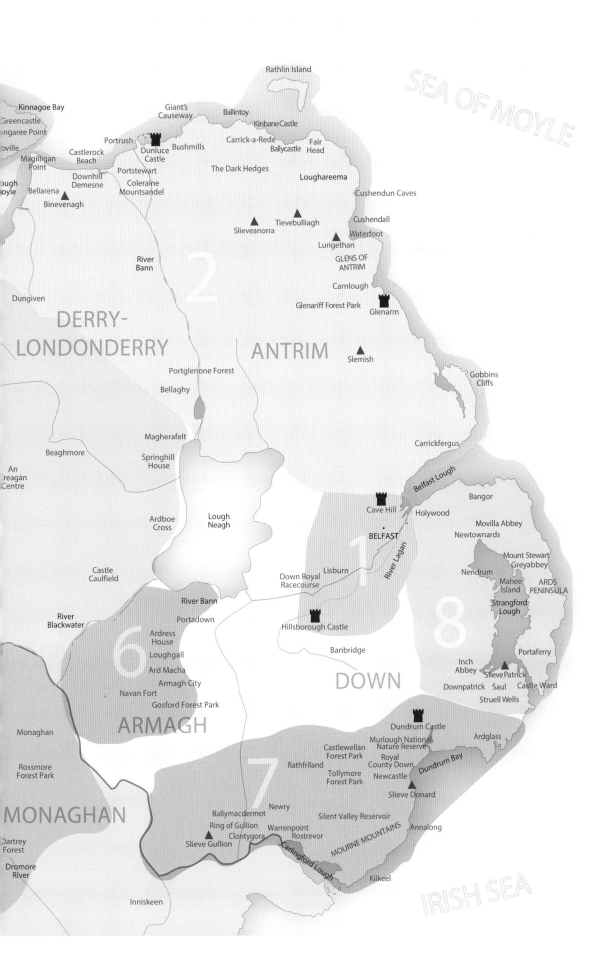

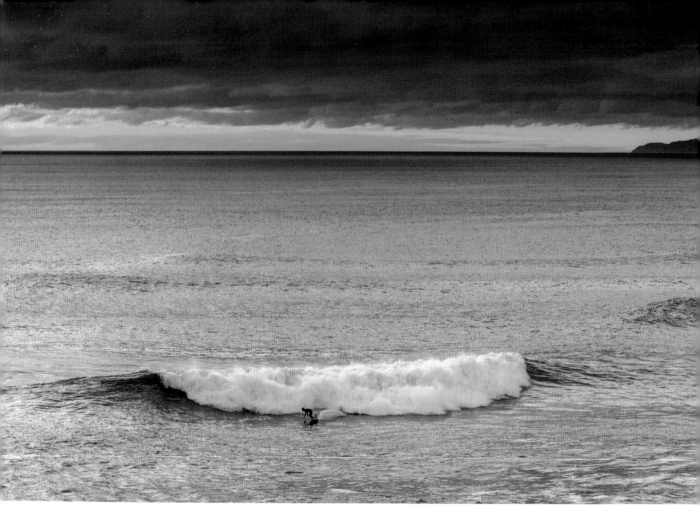

Above and below: A lone surfer tests the Atlantic waves off the Donegal coast, while the rock formations of Whitepark Bay, in County Antrim, intrigue and entice. Ulster's treasured coastal rim is full of delights and surprises.

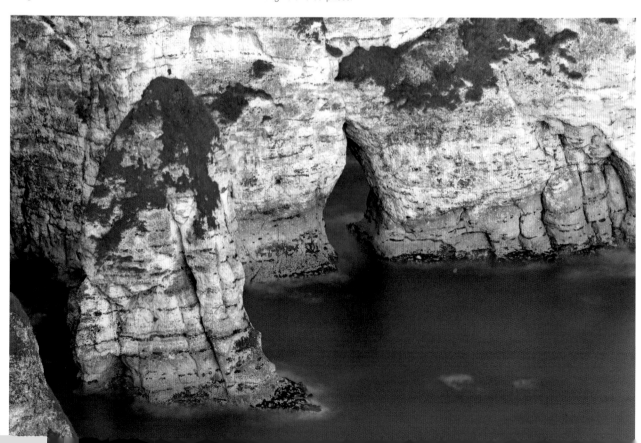

CONTENTS

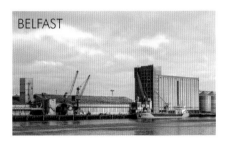

BELFAST

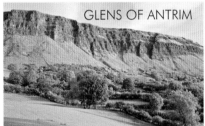

GLENS OF ANTRIM

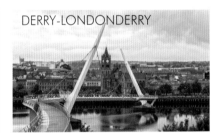

DERRY-LONDONDERRY

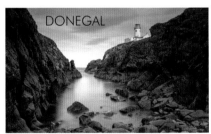

DONEGAL

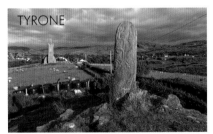

TYRONE

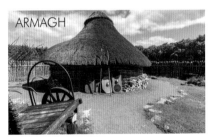

ARMAGH

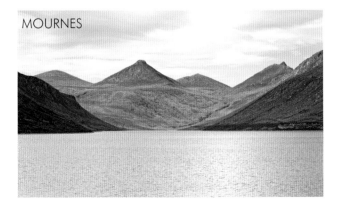

MOURNES

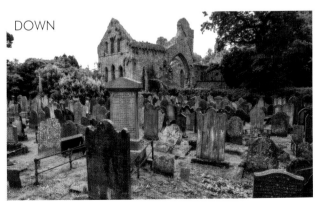

DOWN

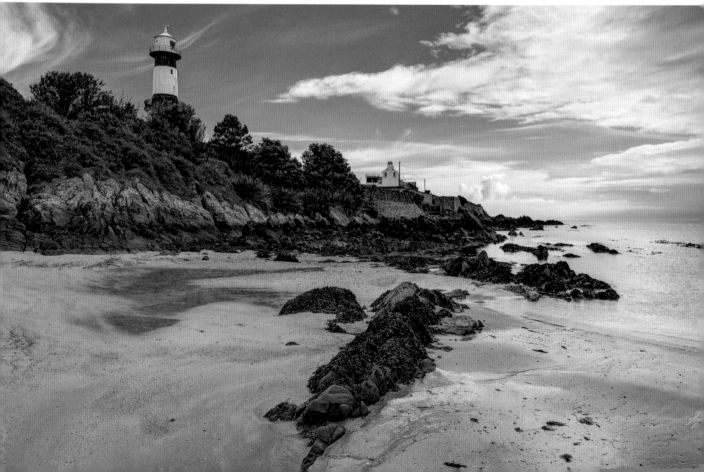

INTRODUCTION

Ulster is the most northerly of the four provinces of Ireland. Its coastline reaches round from Bundoran in the west to Warrenpoint in the east, while its southern border reaches down to Leinster. The province is made up of nine counties: Donegal, Cavan, Monaghan, Tyrone, Antrim, Armagh, Fermanagh, Derry-Londonderry, and Down, the latter six constituting Northern Ireland. This book takes a journey from Northern Ireland into the Republic of Ireland and back again, through many of Ulster's most beautiful and interesting sites.

Ulster's coastal rim shifts between forbidding cliffs, soft beaches, and basalt conundrums, while its interior features mountain ranges, peat beds, rich lowland pastures, and broad rivers. Lough Neagh is the largest lake in the United Kingdom and Ireland, and Strangford Lough the largest sea inlet. At their closest points, no more than 13 miles/20 kilometres separate the north-east coast of Ulster from Britain. West beyond the shores of Donegal, the Atlantic Ocean stretches empty for thousands of miles.

It is a land of turbulent geography and turbulent times. Drama and dispute, laughter, loss, and literature – all are here, in every stone, beneath every footstep.

Culture

Ulster marches and dances, to fiddles, whistles, pipes, lambegs, and bodhráns. No parade is complete without its bands, and many pubs, especially in Donegal and Derry-Londonderry, feature music sessions, either arranged or impromptu.

The province loves language; its poets and writers are revered. Paul Muldoon, a poet who won the Pulitzer Prize, was born in Portadown, County Armagh. Belfast's John Hewitt's verse celebrates the legends and landscapes of Antrim's glens. Belfast was also the birthplace of CS Lewis, creator of *The Chronicles of Narnia*. The poet and novelist Patrick Kavanagh hailed from Inniskeen, in County Monaghan. The village is home to the Patrick Kavanagh Centre and the Kavanagh Trail, which takes in many of the sites that feature in his work. Perhaps the greatest writer of them all, Seamus Heaney, winner of the Nobel Prize in Literature, whose work ploughed Ireland's soil and soul, was born at Mossbawn, near the village of Bellaghy in County Derry-Londonderry. More than 2,000 of the poet's books and other materials are housed at the exhibition and performance space, The Seamus Heaney HomePlace, in Bellaghy.

Another Nobel Prize winner, Dublin-born Samuel Beckett, attended Portora Royal School, in Enniskillen, County Fermanagh, as did Oscar Wilde. The novelist and columnist Brian O'Nolan (Flann O'Brien) was born in Strabane, County Tyrone. The playwright Brian Friel, who wrote *Philadelphia, Here I Come!* among many plays, and was a friend and sometime collaborator of Heaney's, was born in Killyclogher, County Tyrone, and died in Greencastle, County Donegal.

Opposite top: Strangford Lough.
Opposite bottom: Inishowen Lighthouse at Dunagree Point, County Donegal.

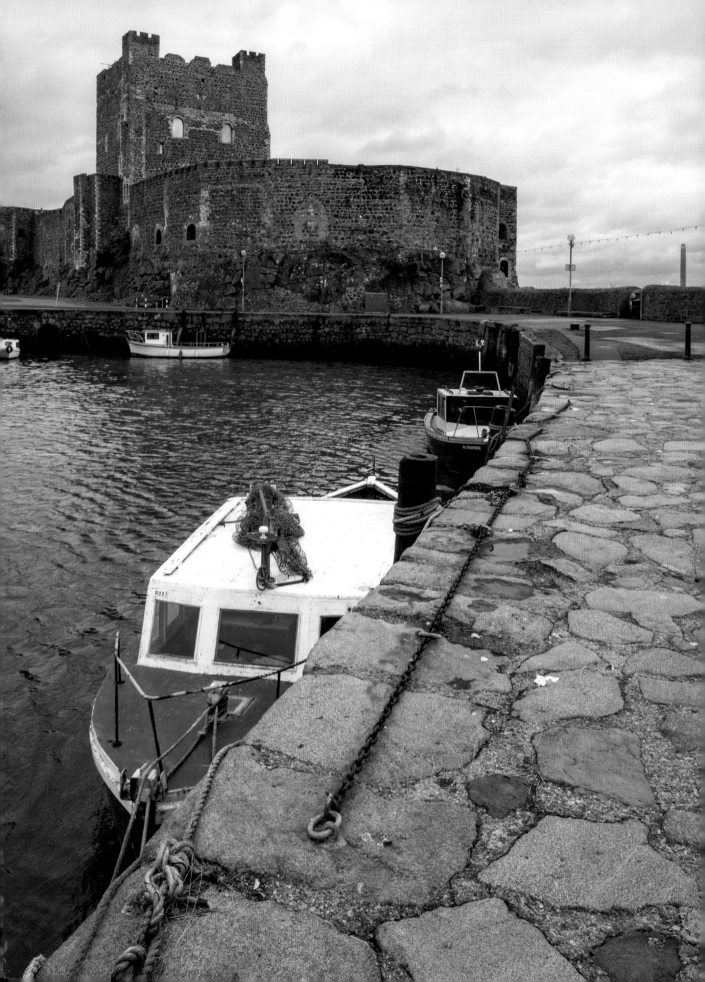

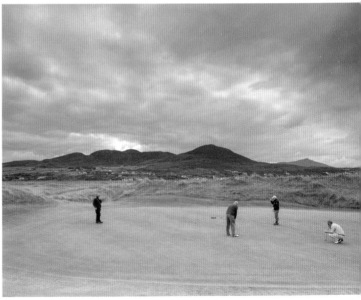

Opposite: Poet and playwright Louis MacNeice, contemporary of WH Auden, Stephen Spender, and Cecil Day-Lewis, was born in Belfast and spent his childhood years in Carrickfergus (pictured here), County Antrim.

Above: CS Lewis, author of the *Narnia* stories, found inspiration in the Mournes: 'I have seen landscapes, notably in the Mourne Mountains … which under a particular light made me feel that at any moment a giant might raise his head over the next ridge.'

Right: Golfers come from all over the world to play in Ulster, drawn by the great courses such as Royal Portrush, and, pictured here, Ballyliffin Golf Club in County Donegal. The entire region has a reputation for producing great players, including Darren Clarke, Graeme McDowell, and Rory McIlroy.

Sport is hugely important throughout the north. GAA clubs are plentiful, and county colours are proudly displayed. The Olympic Gold Medal-winning pentathlete Mary Peters, although born in Liverpool, in England, is regarded as one of Ulster's own. Perhaps the most famous sporting son or daughter of Ulster, however, remains George Best, one of the best footballers of all time, who learned his skills on Belfast's back streets. Other household names include snooker's Alex Higgins, rugby's Willie John McBride, horseracing's AP McCoy, and motorbike racing's legends, Joey and Robert Dunlop.

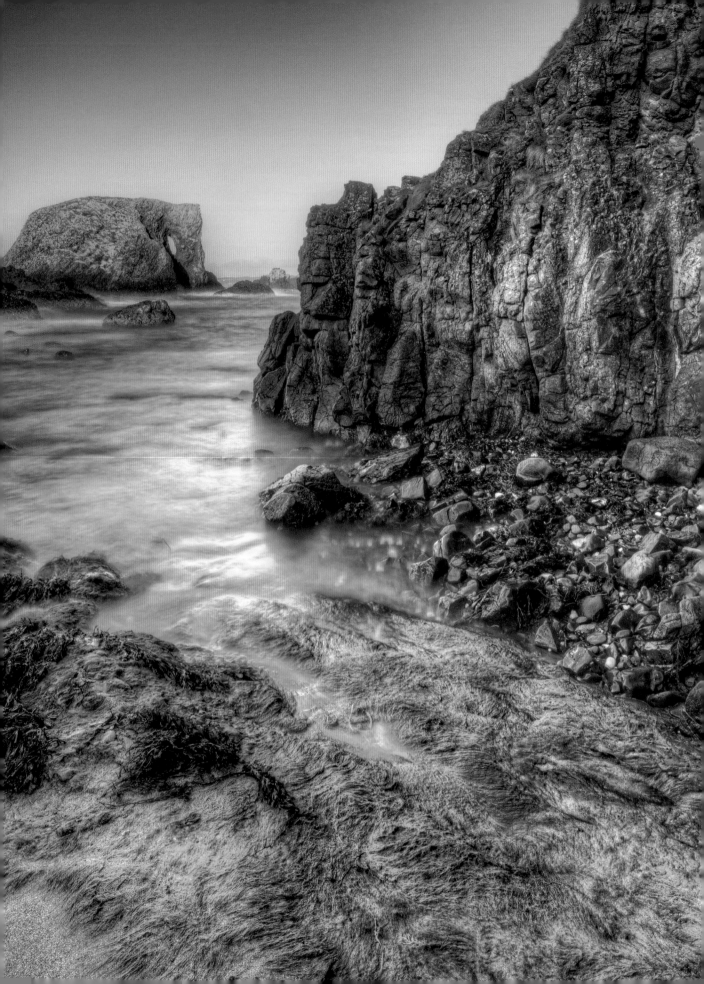

Opposite and above: The rocks tell stories on the Causeway coast, County Antrim: Elephant Rock at Ballintoy and dark shapes at Ballycastle.

Legends of Ulster

Narratives drive Ulster, and deeds and actions continue to be chronicled in story and song to this day.

Some of the oldest stories are contained in the Ulster Cycle, which deals with the Ulaid dynasty of north-east Ireland, from which the province derives its name. Cú Chulainn, the Hound of Ulster and the most feared of the Red Branch Knights, is the hero of many tales, most notably the *Táin Bó Cúailnge* (*The Cattle Raid of Cooley*), in which he slays the finest soldiers Connacht can muster as they invade Ulster to seize the magnificent Brown Bull.

The Mythological Cycle includes *The Children of Lir*, which sees Fionnuala and her brothers transformed into swans by Aoife, their envious stepmother, and cursed to spend centuries on wild waters, separated from their beloved father. The second of their miserable sojourns was spent on the Sea of Moyle, between Ulster's Antrim coast and Scotland.

And in the Fianna Cycle, Fionn Mac Cumhaill creates the Giant's Causeway as a route to Scotland for an encounter with the resident Scottish giant. In another feat, he scoops up a handful of earth to fling at his rival, and the missile lands in the Irish Sea, thus creating the Isle of Man. The crater he left in the ground filled with water and is now Lough Neagh.

Game of Thrones

Legendary giants, monsters, and brutish armies still stalk the land of Ulster, but today the vicious power struggles are carefully choreographed for a worldwide television audience.

The region has a booming cinema and television industry, with acclaimed programmes and films such as *The Fall*, *Line of Duty*, and *Philomena* all being filmed here. However, it is *Game of Thrones* that has attracted the most attention, and much of it is made in Ulster. The show has garnered an

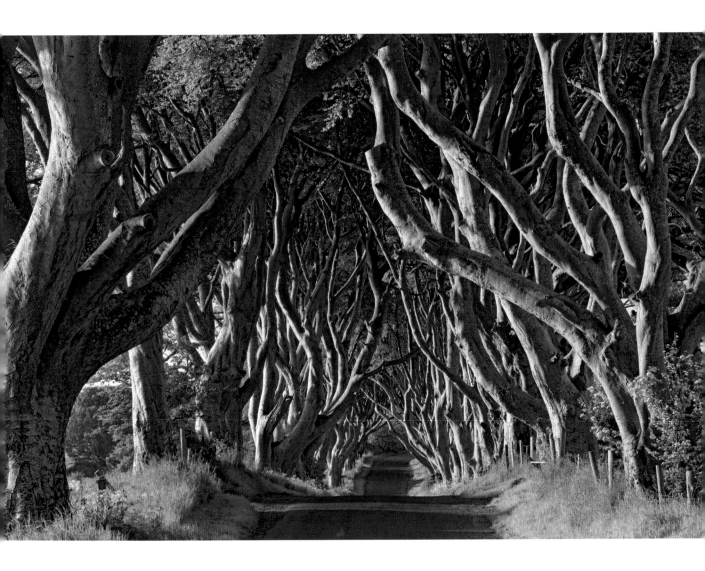

Above: The surreal avenue of The Dark Hedges, County Antrim.

array of awards and millions of viewers, many of whom come to Ulster to see the locations used in the programme.

The demand is such that a whole industry has quickly grown to take visitors around Ulster, or Westeros, as many now know it. Sites along the north-east coast feature in many iconic scenes: Downhill Strand, watched over by Mussenden Temple, Carrick-a-Rede, the Cushendun Caves, and further inland, the avenue of the magnificent and eerie Dark Hedges are just some examples.

Castle Ward, in County Down, doubles as Winterfell, and visitors can experience a replica of the Winterfell archery range and take a cycle tour of nearby locations. Further to the south-west, where the Mourne Mountains begin to rise, is Tollymore Forest Park, whose cooling glades also feature in the series.

An even bigger screen franchise has come to Ulster, however. Scenes from *Star Wars: Episode VIII* have been filmed at Malin Head, bringing fans flocking for a glimpse of a stormtrooper, or a photograph of the Millennium Falcon.

Worship in Ulster

The Spire of Hope strikes the sky from the roof of St Anne's Cathedral, Belfast, a symbol of the light and promise of Christianity.

Centuries before it was placed there in 2007, Ireland was known as the land of saints and scholars. Throughout Ulster, the signs and symbols of Christian worship remain, in age-old, moss-covered stone crosses, in ruined abbeys, in placenames, and shrines.

Ireland has three patron saints: Brigid, Patrick, and Colmcille, and tradition places the burial site of all three in the graveyard of Down Cathedral. The stories of Colmcille and Patrick are inextricably linked to Ulster. Colmcille lived his life here before sailing to Iona. St Patrick established his church in Armagh, which remains to this day the ecclesiastical centre of all Ireland, and pilgrims still walk and drive St Patrick's Trail through Armagh and Down.

Pre-Christian worship is also very much in evidence, with people in increasing numbers coming to see portal tombs, stone circles, and burial mounds throughout the province. Armagh was Ulster's ancient capital, and the Navan Centre there tells of many pagan rituals.

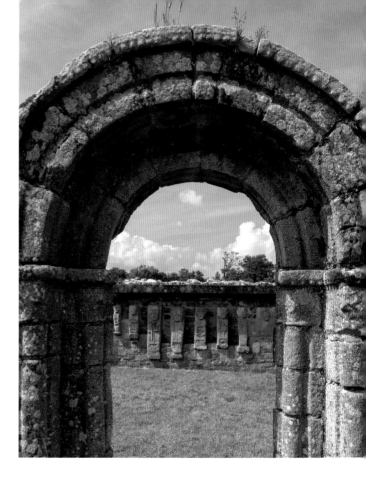

Above: Through the Romanesque archway of an ancient ruin on White Island, Lough Erne, can be seen a series of enigmatic carved figures, dating perhaps to AD800, their Christian symbolism possibly infused with pre-Christian references.

Below: Nendrum monastery, Mahee Island, in Strangford Lough.

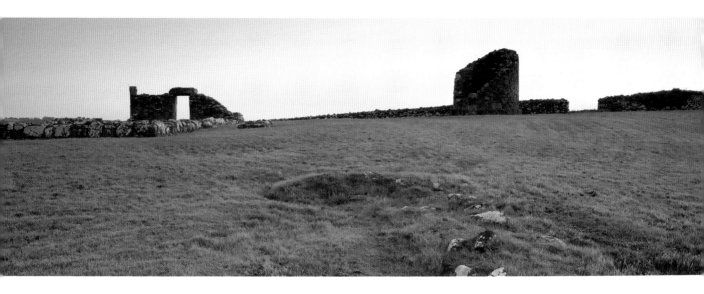

Above: Ulster's shores have seen many a desperate departure. Defeated on the battlefield, harried by their enemies, betrayed by informers, in 1607, Hugh O'Neill of Tyrone and Rory O'Donnell of Tyrconnell left Ireland from Rathmullan, on Lough Swilly, in what became known as the Flight of the Earls. Having failed in their search for help from the French and Spanish in their fight against the English, they lived out their days in Rome. **Below:** Strangford Lough.

History

Few countries have peaceful histories, but Ireland's history is more turbulent than many, and Ulster's story is arguably the most troubled of all the four provinces, experiencing invasion, settlement, conflict, famine, emigration, yearned-for and uneasy peace.

Ireland's oldest known settlement is at Mountsandel, in Coleraine, dating to around 7000BC. Much later, Celtic peoples crossed to Ulster, followed in turn by Vikings, and then Normans. Gaelic traditions and kingdoms survived until, worried about a threat from the west, and eager to extend their power, the Tudor rulers of England began concerted efforts to bring Ireland to heel, with Henry VIII claiming the island as his own.

Centuries of displacement and conflict were well underway. Plantation schemes were enacted, with Scottish and English Protestants and Presbyterians drafted in to farm the land taken from the native Catholic Irish. Although tensions between religions have rarely dipped beneath the surface, the human story is complex and never simply black and white. In the 18th century a number of liberal members of the Protestant Ascendancy organised the United Irishmen with a view to parliamentary reform and the implementation of Catholic rights; they were joined by Catholics in the failed rebellion of 1798.

As the 19th century progressed tensions grew throughout Ireland, with demands for and against Home Rule. Many Ulster Protestants were opposed to Home Rule, and armed groups formed to defend their wishes. A War of Independence throughout Ireland followed the 1916 Easter Rising in Dublin. In what was thought to be a short-term measure, the island was partitioned, and the new state of Northern Ireland formed in 1921.

The new state consisted of six of Ulster's nine counties. Tyrone, Down, Fermanagh, Derry-Londonderry, Armagh, and Antrim, with a Protestant majority favouring continued union with Britain, were separated politically from Cavan, Donegal, and Monaghan. Catholics in the north saw their rights and opportunities severely restricted.

The Civil Rights movement of the 1960s organised demands for the rights of Catholics in the north. Ongoing conflict led to the bloodshed of the Troubles, until the signing of the Good Friday Peace Agreement in 1998, and the establishment of a power-sharing assembly at Stormont.

Ins and Outs, The Ulster-Scots

Traffic and trade have flowed between Scotland and Ulster for hundreds, and perhaps thousands, of years. The close ties between the two lands were most firmly cemented in the 1600s, during the Plantation of Ulster, which saw many Scottish farmers arrive to take up land in the nine counties.

And so developed a people – the Ulster-Scots – and with them a language which blended Scots and English and which can still be heard today, particularly in the Ards Peninsula, north Down, north County Derry-Londonderry, County Antrim, and east Donegal, and read in the work of the Weaver Poets, such as James Orr. The identity, culture, and traditions of the Ulster-Scots remain strong, not just in Ulster, but in places such as Canada, the United States of America, and New Zealand, to which many emigrated from the early 1700s onwards.

The influence of the Ulster-Scots is particularly notable in the United States, with a number playing a key role in the American War of Independence, fighting against the crown. Many famous US figures were of Ulster-Scots ancestry. Davy Crockett's forbears came from Castlederg, and a number of presidents, among them Andrew Jackson, Ulysses S Grant, and Woodrow Wilson, also traced their ancestry back to Ulster.

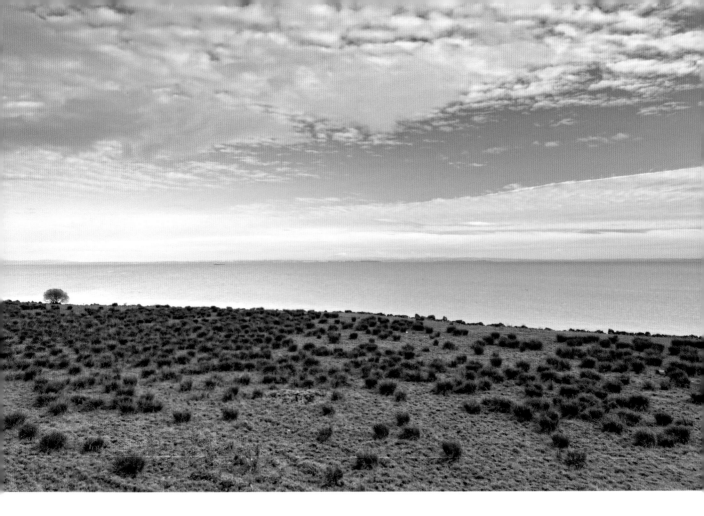

Lough Neagh

Five of Ulster's nine counties border Lough Neagh: Derry-Londonderry, Antrim, Down, Armagh, and Tyrone.

Every year, thousands of eels make the journey to Lough Neagh from the Sargasso Sea in the Atlantic, making it Europe's largest source of wild eels. The first product in Northern Ireland to be awarded Protected Geographical Indication status, Lough Neagh eels are considered a real delicacy.

Six rivers feed into the lough, with the Lower Bann being the only one to leave it. There are wetlands here of international significance, full of wintering birds, shrubs, and wild flowers. The Lough Neagh Discovery Centre, Peatlands Park, and Oxford Island Nature Reserve are full of fascinating information and offer the chance to see the habitat at close quarters. Boat trips run to Ram's Island and Coney Island, and the Loughshore Cycling Trail runs around the lake.

Ulster holds within it an enthralling array of sights and stories, possibilities and pleasures. Divided into eight broad geographical regions, this book aims to guide you through some of those temptations and to lead you towards others. Beginning with the civic grandeur of Belfast, we travel along the Causeway Coastal Route, past the mighty Glens of Antrim, to Derry-Londonderry and the charms of Inishowen. Beyond, there lie the wilds of Donegal and its coast, lashed by the waves which draw surfers from all over the world. We then head back east through the richness of the Sperrins and the calmness of the Fermanagh Lakes, taking in the unheralded beauty of Cavan and Monaghan on the way to the orchard country of North Armagh and the inspirational Mournes, before ending our journey where St Patrick began his, in Downpatrick and North Down.

Opposite top: Around 19 miles/30 kilometres long, with a maximum depth of just under 30 metres/100 feet, covering an area of 150 square miles/390 square kilometres, Lough Neagh is the largest lake in Britain and Ireland, and one of the biggest in Europe. **Above:** Gortin Glen, Sperrin Mountains, County Tyrone. **Below:** Whiterocks, Portrush, County Antrim.

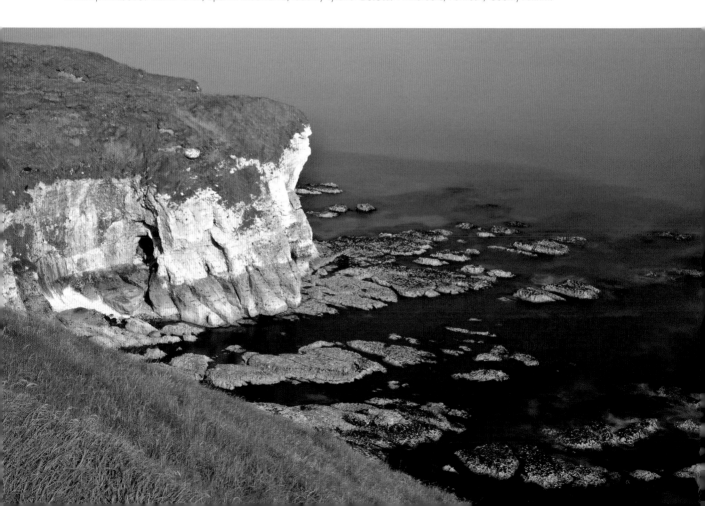

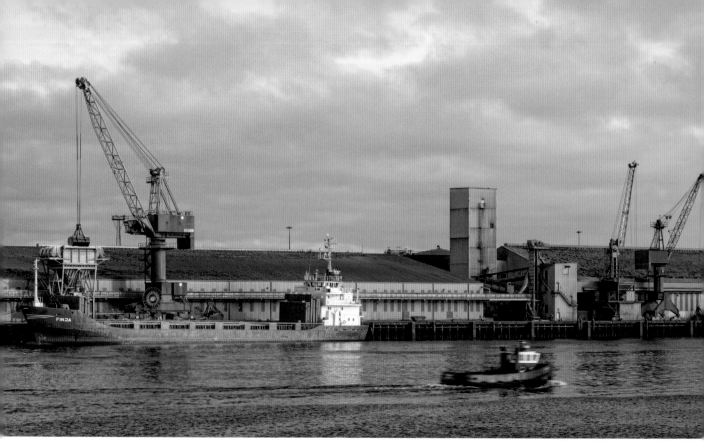

Above: The Belfast docklands. The Lagan river was the engine that drove the economic growth of the city. Wool, linen, and foodstuffs all left the city by ship, and in came tobacco and sugar. **Below:** A prominent feature of the Belfast skyline, one of two shipbuilding gantry cranes known as Samson and Goliath.

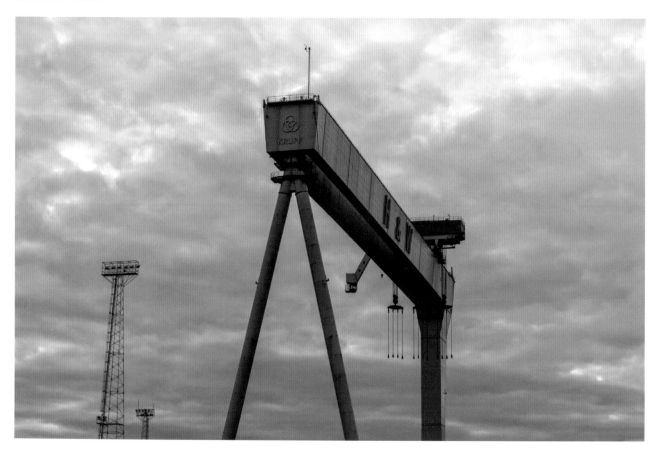

BELFAST

Archaeological evidence suggests the plains on which Belfast stands have been inhabited for as many as 5,000 years, but the settlement which grew into the city we know today is only around 400 years old.

Belfast takes its name from the River Farset. That river now flows, largely forgotten, beneath the city's streets, long since superseded by the Lagan, which runs through the heart of Northern Ireland's capital and out into Belfast Lough.

The Titanic Quarter

From the mid-1800s, shipbuilding became one of Belfast's major industries. At its height, Harland & Wolff employed 35,000 people, building and repairing ships vital to the Allied effort in World War Two. Its beautiful drawing offices and two massive cranes, Samson and Goliath, which dominate views from all parts of the city, stand as witness to the company's triumphs.

It is, however, for the construction of the RMS *Titanic* that the company will always be best known.

One of three Olympic-class liners, the *Titanic* was designed and built by Harland & Wolff for the White Star Line. As the city likes to say, it was fine when it left Belfast, but, just days into its maiden transatlantic voyage, the *Titanic* struck an iceberg and sank, with the loss of over 1,500 lives.

While a monument to those lost stands in the grounds of Belfast City Hall, it is in the Titanic Quarter that the experiences are most vividly captured.

Below: Titanic Belfast, a magnificent six-storey building the design of which recalls both the ship and the agent of its downfall. Nine galleries tell the story of perhaps the world's most famous ship, from design and construction to launch and despair, including a recreation of a first-class cabin and interactive displays showing the resting place of the ship on the ocean floor.

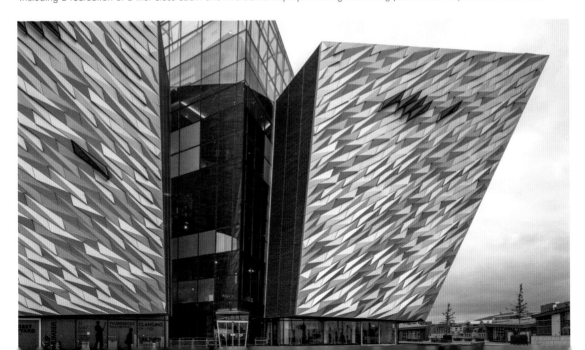

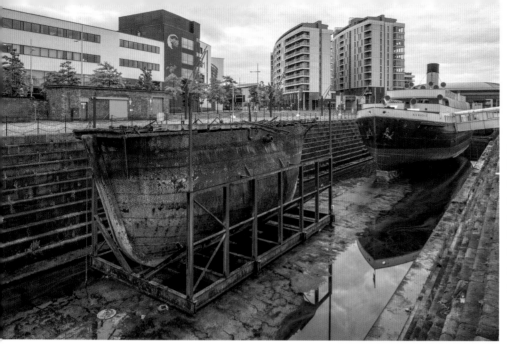

Left: The Thompson Graving Dock in the Titanic Quarter, once the biggest in the world, where the *Titanic* and her sister ships were fitted out. And here too is the *Nomadic*, the tender which ferried passengers to the doomed liner as it prepared to set sail.

One of the most popular attractions at Odyssey, in the Titanic Quarter, is W5, a science and discovery centre. It offers an enthralling and exciting experience for the entire family, with over 250 interactive exhibits and regular science demonstrations, encouraging and enabling young and old alike to explore the world around them.

Cave Hill, Belfast Castle, Belfast Zoo

High above Belfast stands Cave Hill. The walk to the top is rewarded with a fabulous view of the entire city spread out by Belfast Lough. Belfast Castle is to be found in Cave Hill Country Park. Here too is Belfast Zoo, with around 150 species, including Barbary lions and red pandas.

Right: Cave Hill Country Park is home to Belfast Castle, built in the Scottish baronial fashion by the Marquis of Donegall in 1870, and owned by the Shaftesbury family from 1884 to 1934 when it was presented to the city.

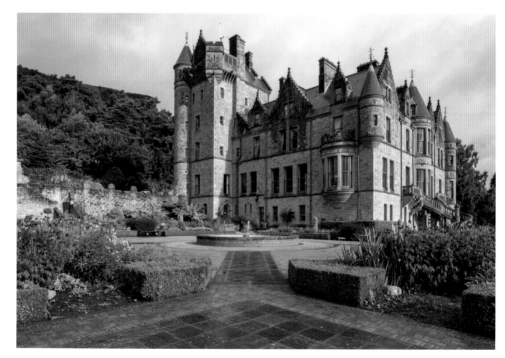

City Hall and Beyond

At the heart of Belfast is City Hall, begun after city status was granted in 1888, and opened in 1906. Built in stone and marble, its forceful columns, classical symmetry, elegant statues, and detailed ornamentation suggest pride and power.

The Europa Hotel, on nearby Great Victoria Street, is a bold, brave, and colourful statement of the city's endurance that has welcomed presidents through its doors. Opposite is another of the city's iconic sites, the Crown Bar, a Victorian jewel of opulent décor and expertly pulled pints.

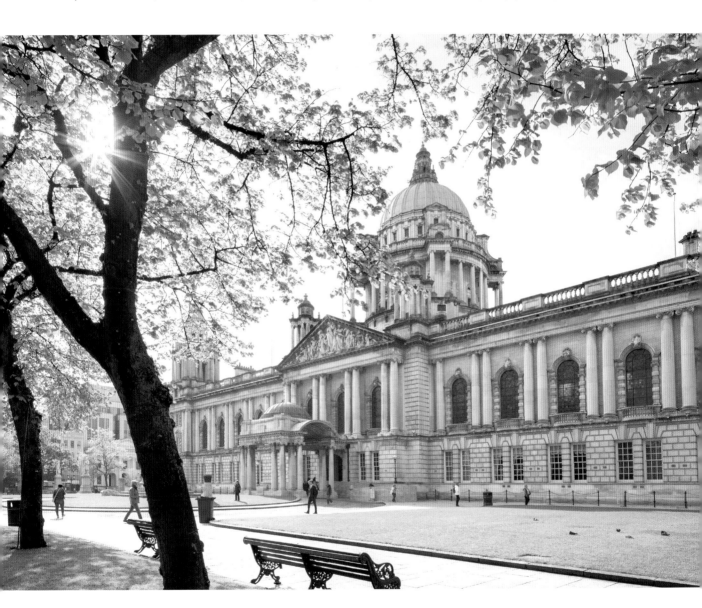

Above: The lawns of City Hall attract workers and tourists. Knowledgeable guides lead tours of the interior, and a dazzling perspective can be gained from the rotunda viewing gallery.

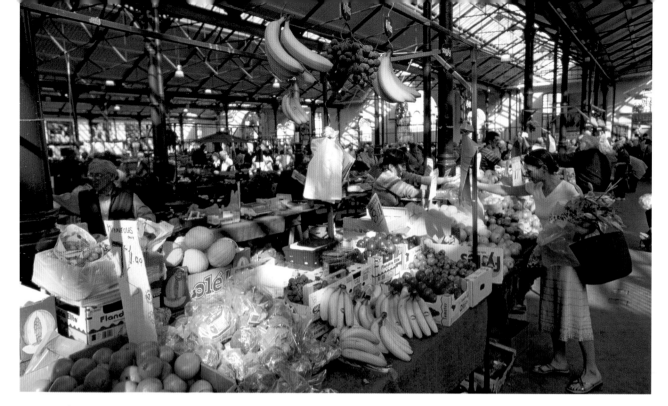

Above: The award-winning covered St George's Market, offering fresh food, clothes, art, and antiques, brings throngs of people through its doors on Fridays, Saturdays and Sundays. A range of freshly cooked food is there to tempt, to a soundtrack of live music.

The Cathedral Quarter

Belfast is a copper-topped city, the green domes of the churches and civic buildings bringing a special lustre to the skyline. One building, however, dares to be different. Since 2007, the simple, stainless steel Spire of Hope spikes high into the sky from the roof of St Anne's Cathedral. Illuminated at night, the spire represents hope and light for the world.

Belfast's Cathedral Quarter emanates from St Anne's. The old buildings house vibrant bars, cafés, restaurants, and small, creative workshops. The Quarter is home to the MAC, a cutting-edge arts centre that boasts two theatres and three galleries.

Below: St Anne's Cathedral was consecrated in 1904, although 50 more years would pass before the building was completed. St Anne's contains beautiful stained-glass windows, a marble maze signifying life's journey, and elaborate mosaics.

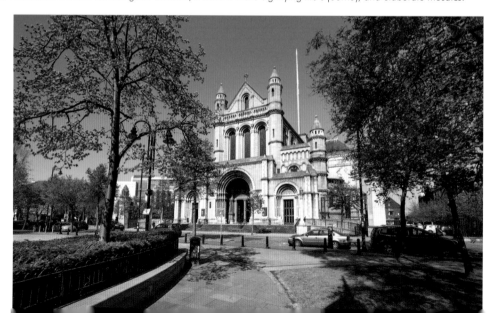

Taxi Tours

Taxis offer tours of the city, among the most popular being the black cab tours, providing an insight into Belfast. While the tours visit the main areas of interest, the murals that fill many of the city's walls remain a highlight. In both Nationalist and Unionist areas of the city, these giant murals – public, citizen artworks – depict the moods and concerns of the people, and the historic events that have moulded the city.

Crumlin Road Gaol is another fascinating stop. On the fringes of the city centre, it ceased to be an operational prison in 1996 but, for 150 years prior to that, it held Republican and Loyalist inmates alike, as well as murderers and suffragettes, and saw hunger strikes, riots, and executions. Visitors can walk the tunnel that leads under the road from the courthouse to the jail, experience life on C-Wing, and linger in the hanging cell that was the last room of condemned men.

Queen's University

South of the centre is Queen's University. Although its roots reach back to 1810, Queen's, or QUB, opened in 1849. The red-brick, gothic Lanyon Building is at the centre of the university, creating an atmosphere of learning that pervades the area.

Queen's is neighbour to the Ulster Museum. The permanent collections cover the art, history, and natural history of Ireland. Ceramics, glass, paintings, sculpture, textiles, and silver dating from the early 1600s are all on display, as are ancient rocks and fossils, and examples of the native plant and animal life. The human history section pays particular attention to Ulster since 1600, and Northern Ireland from its creation in 1921.

By the banks of the Lagan, the Lyric Theatre has won multiple awards for its productions. The building, full of angled planes and surprising spaces, was nominated for the Stirling Prize for architecture.

Below: The Parliament Buildings of Stormont stand at the end of a long, straight drive. Designed with deliberate symbolism, the building is 111 metres/365 feet wide, a foot for every day of the year, and is fronted by six pillars, one for each county of Northern Ireland.

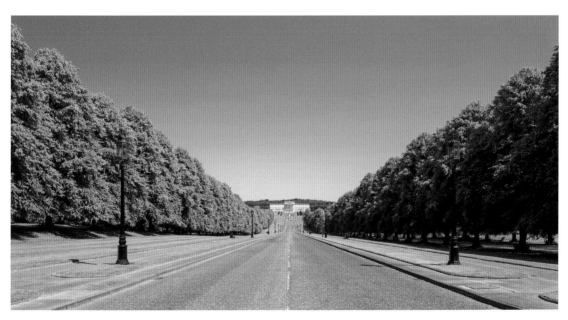

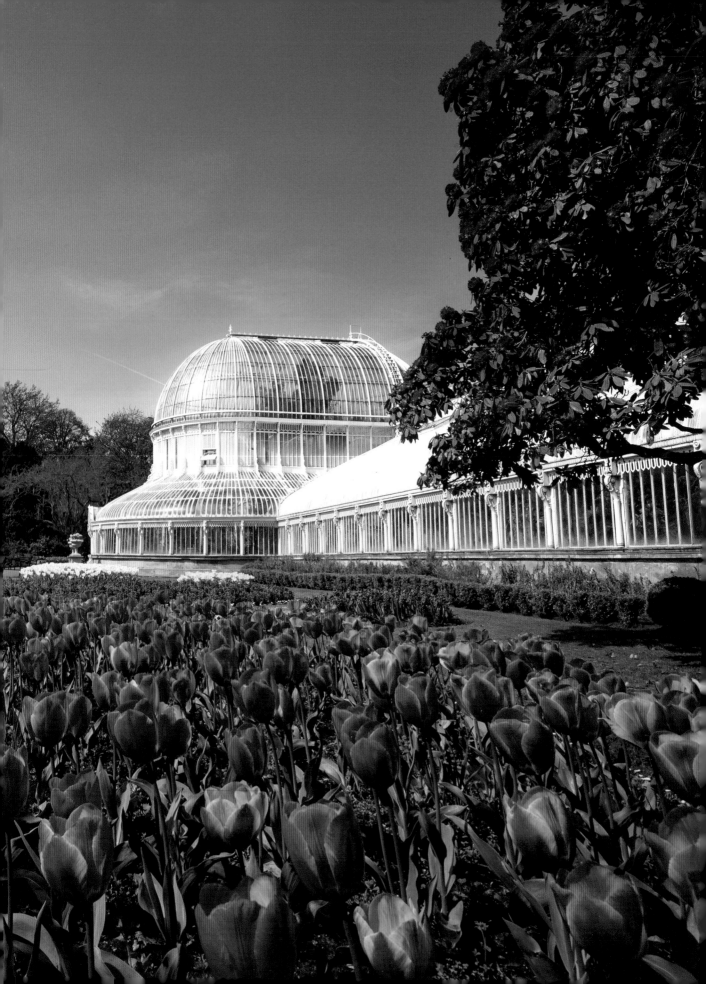

Opposite: The Ulster Museum sits within the Botanic Gardens, a haven of rose gardens and bright borders. The Palm House, designed, like the main building of QUB, by Charles Lanyon, is one of the earliest examples of its kind, completed in 1840. Within are birds of paradise and tropical plants, while the Tropical Ravine contains bananas, orchids, tree ferns, and flowering vines.

Stormont and Hillsborough

Designed in the Greek Classical style and opened in 1932, Parliament Buildings, known simply as 'Stormont', is now the home of the Northern Ireland Assembly, established after the Good Friday Agreement of 1998. Open to visitors, free guided tours are available at certain times of the year.

Not far outside Belfast, to the south of Lisburn, is Hillsborough Castle, the official residence both of the Secretary of State for Northern Ireland and the Royal Family. Tours can be made of the elegant interior, which held many of the formal and informal discussions of the peace process.

Nearby

The Ulster Folk and Transport Museum is about 7 miles/11 kilometres north-east of Belfast city centre. The museum explores the region's social, domestic, and work history, its rural traditions, and the vehicles, commercial and passenger, that have been used or developed here. The exhibits, part of one of Europe's largest transport collections, include a vertical take-off Short's SC1, and a DeLorean sports car, built in Belfast. East of Belfast, in Dundonald, the Old Mill retains a restored water wheel and, with its café and gift shop, is a welcome stop on the road.

Below: Skelton Rainey bandstand in Jordanstown Loughshore Park, Newtownabbey, north of Belfast – a popular park stretching along the shoreline.

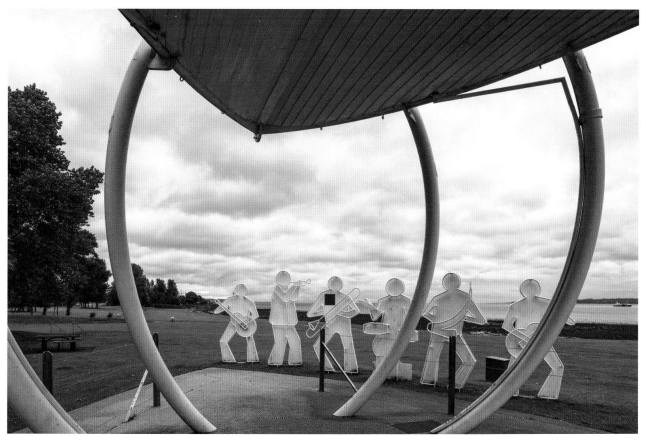

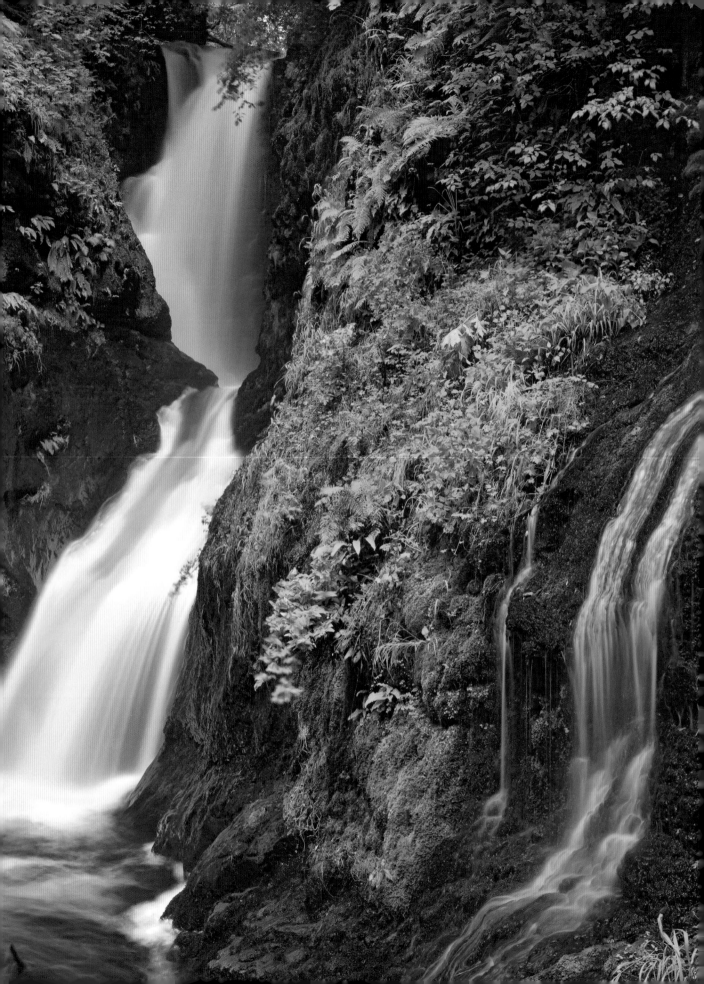

GLENS OF ANTRIM AND CAUSEWAY COASTAL ROUTE

The Antrim Plateau spreads starkly around the north-east corner of Ulster, girded by cliffs, and skirted by the Causeway Coastal Route, which runs from Belfast to Derry-Londonderry. Cutting east and north-east down to the sea are the nine Glens of Antrim: Glentaisie, Glenshesk, Glendun, Glencorp, Glenaan, Glenballyeamon, Glenariff, Glencloy, and Glenarm.

THE GLENS OF ANTRIM

Some of the names resonate. The placenames tell their own stories: Glentaisie in honour of the princess Taisie from Rathlin Island; Glenshesk, 'glen of the sedges'; Glendun, 'glen of the brown river'; Glencorp, 'glen of the slaughtered'; Glenaan, 'glen of the colt's foot'; Glenballyeamon, 'Edwardstown glen'; Glenariff, 'the arable glen', dubbed Queen of the Glens; Glencloy, 'glen of the hedges; and Glenarm, 'glen of the army'.

Beauty and Contrast

Lying within a designated Area of Outstanding Natural Beauty, the glens hold a rich variety of flora, fauna, and landscape – from gentle slopes, sheer drops, and rocky gorges to rich farmland and wild, challenging moors. Walkers, anglers, and nature-lovers, photographers, writers, and artists are all drawn here, many staying in the towns and villages that punctuate the glens, such as Glenarm, Carnlough, Waterfoot (Glenariff), Cushendall, Cushendun, and Ballycastle.

Opposite: Ess-na-Larach Waterfall rushes into the river winding along the Glenariff valley floor, and plants cling to the rocky walls. **Below:** Cushendall at the foot of Tievebulliagh on Red Bay.

At all times of the year, plants bring colour to the glens – orchids, bright yellow gorse, bluebells, butterwort, primroses, and thistles. Grouse, harriers, falcons, kingfishers, buzzards, and larks are just some of the birds that can be seen.

Opposite top: Glendun in autumn.

Opposite bottom: Portglenone Forest, near Ballymena, with bluebells in full bloom.

Right: The rivers of the glens are noted for salmon and trout, and the moors and heaths are home to foxes, badgers, stoats, rabbits, and hares.

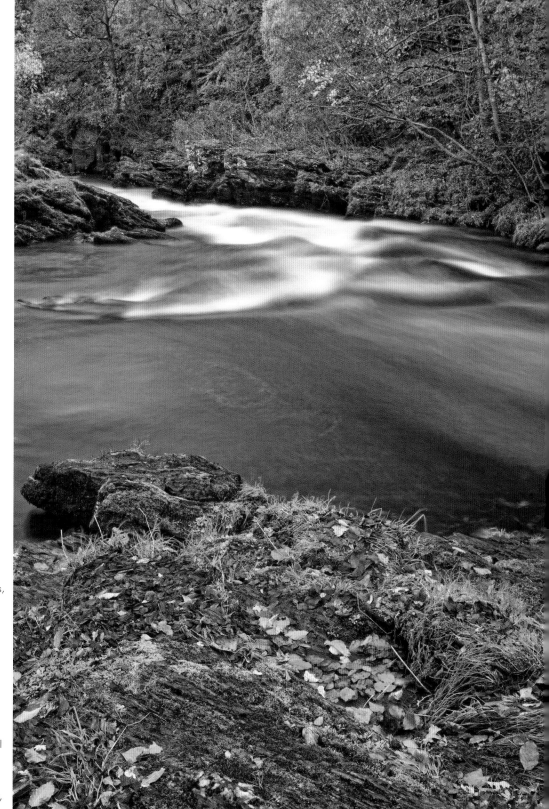

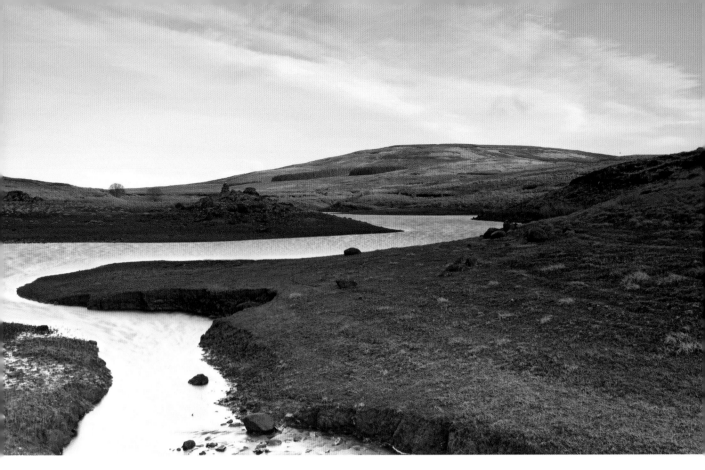

Above: The vanishing lake of Loughareema. In 1898, a carriage disappeared while crossing the lake, with horses and passengers all lost, and many since have claimed to have seen the spectre of the coach and horses patrolling Loughareema's banks.

Magical Stories

This is a land, too, of legend and folk tales and local lore.

Glentaisie, so traditional stories have it, recalls Princess Taisie, the beautiful daughter of Rathlin Island's King Dorm, whose wedding to Congal, heir to the crown of Ireland, was savagely attacked by the jealous King of Norway, come with his army to claim Taisie for himself.

Part-human, part-fairy Grogochs are said to have settled in Antrim when they crossed to Ulster from Kintyre. Thoughtful and convivial, they help with the harvest and jobs around the house. The sight of a hawthorn tree is not uncommon, even in areas where all else has been cleared; superstition persists that cutting down a hawthorn will bring swift retribution from the fairies.

Harder evidence is available of Loughareema, the vanishing lake near Ballycastle. Named among the Geological Society's top 100 geological sites in the UK and Ireland, the lake fills and drains with extraordinary speed, the reason for which remains up for debate.

Mountains of the Glens

Between Glenaan and Glenballyeamon, inland from Cushendall, is Tievebulliagh mountain. Archaeologists have uncovered evidence of a 3,000-year-old quarry. Porcellanite was extracted there and fashioned into sharp-edged, highly polished axes.

Inland from Glendun and Glenaan is Slieveanorra, which gives its name to the close-by coniferous forest, one of many throughout the glens. Tracks provide an inviting route to the summit, rewarding the walker with panoramic views of Antrim and beyond.

Above: Glenariff, dubbed by many as Queen of the Glens, with to the north the long, high slab of Lurigethan, which has the remains of an Iron Age fort, one of many such ancient settlements in the region. **Below:** Slemish Mountain is close to the start of Glenarm. It is known as St Patrick's first home in Ireland. Brought here as a slave from his home in Britain, he tended sheep on Slemish, where, in his misery and desolation, he prayed for escape. Each year, on his feast day on 17 March, pilgrims come to Slemish in honour of Ireland's patron saint.

WITHIN AND BEYOND THE GLENS

Glenarm Castle

In 1242, when John Bisset was exiled from Scotland for committing murder, he made his way to Ulster, where he settled in Glenarm, building a castle there in 1260. Acquired by the McDonnells in the 16th century, invasion, battle, fire, shifts of location, rebuilding, and renovation followed, leading to the present-day castle, the ancestral home of the Earls of Antrim, standing just outside the town of Glenarm. The exterior and interior reveal a range of styles, reflecting the development of the building over the years. Host to a renowned annual highland games, as well as concerts throughout the year, the castle is particularly noted for its walled garden, open to the public throughout the spring and summer.

The Dark Hedges

Along Bregagh Road, between Ballycastle and Ballymoney, lie The Dark Hedges, a beautiful avenue of beech trees planted in the late 1700s by the Stuart family to impress visitors to Gracehill House. From either side of the road, the trees have grown to meet, forming a canopy. The twisted, distorted branches create an eerie sense of cold vulnerability and unseen danger.

Opposite: The ghost of the grey lady passes in and out of the trees of The Dark Hedges, never leaving their confines. Some say she is Cross Peggy, daughter of the man who built Gracehill; others profess she is a maid, the mystery of whose death was never solved. On Hallowe'en she is joined among the hedges by the souls from a nearby graveyard. **Below:** Glendun viaduct.

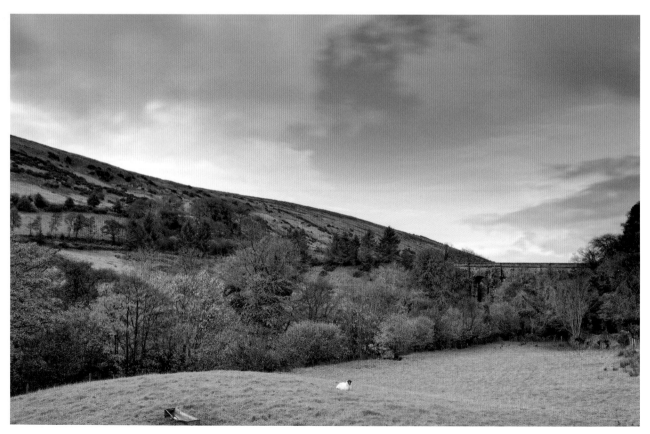

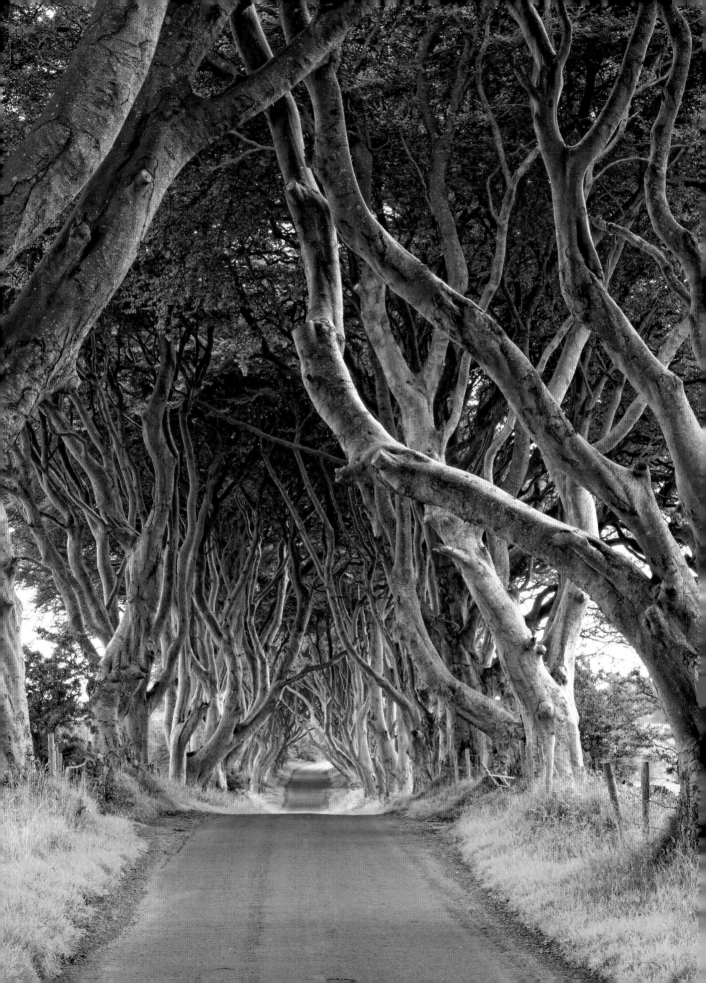

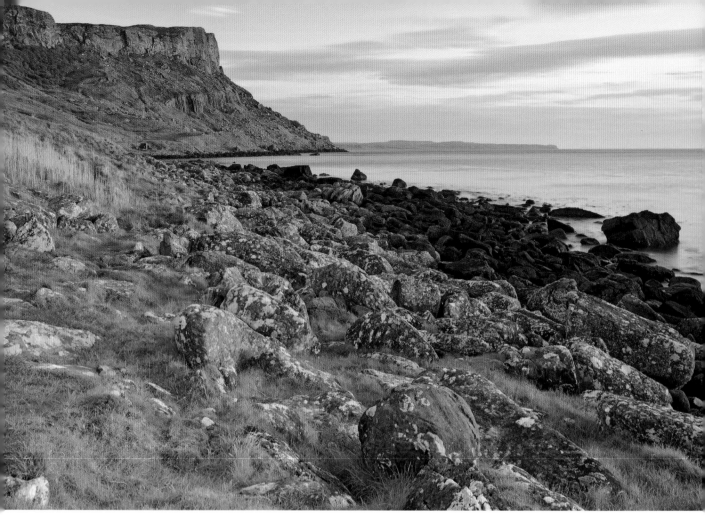

Above: Magnificent to see and to look out from, Fair Head is regarded as one of the finest headlands in Britain and Ireland, attracting intrepid walkers to its paths and daring climbers to its craggy face.

THE CAUSEWAY COASTAL ROUTE

The Causeway Coastal Route is a designated way-marked drive between Belfast and Derry-Londonderry, hugging the coastline wherever possible, tight with the waters of the Irish Sea, the Atlantic, and Lough Foyle. A journey along the much-fêted route sees the country taking on and shedding guises – seaside jollity, soft charm, stern majesty – and opens up a world of ancient and modern stories, perilous existence, awesome geology, defiant ruins, rich wildlife, and enduring crafts. Within the route sits the Causeway Coast Way itself – a walking trail between Ballycastle and Portstewart, which takes its name from the World Heritage Site of the Giant's Causeway, and passes through the Causeway Coast Area of Outstanding Natural Beauty.

The Gobbins

The Gobbins Cliffs look down on the Irish Sea from the east face of the Islandmagee Peninsula, about 20 miles north of Belfast, in County Antrim. Only yards above the sea, down a steep climb, runs the Gobbins path, a series of walkways, tunnels, and bridges along the cliff-face and over white, wild water with views to Scotland.

Rathlin Island

Deposed by Edward I, excommunicated by the pope, his brothers executed and his wife and daughters imprisoned, Robert the Bruce fled his kingdom of Scotland, in 1306, and sought refuge on Rathlin Island, 6 miles/10 kilometres off the Antrim coast.

Legend has it he took inspiration from a spider's repeated attempts to ascend a cave wall on the island, and he returned home to reclaim his crown, and defeat the English army at Bannockburn in 1314. Bruce's Cave as well as the ruins known as Bruce's Castle can still be seen on Rathlin.

Home to a Royal Society for the Protection of Birds (RSPB) centre, the island is noted for its spring invasion of seabirds. From April onwards, Rathlin is alive with guillemots, shags, razorbills, and, especially, puffins. A ferry runs from Ballycastle, and is frequently accompanied by pods of dolphins.

Above: The oldest on Rathlin Island, the East Lighthouse at Altacarry stands above Bruce's Cave and began operations in 1856. A Marconi Station was later established here, transmitting news of passing ships to Lloyd's of London.

Below: Grey seals are a common sight off Rathlin Island.

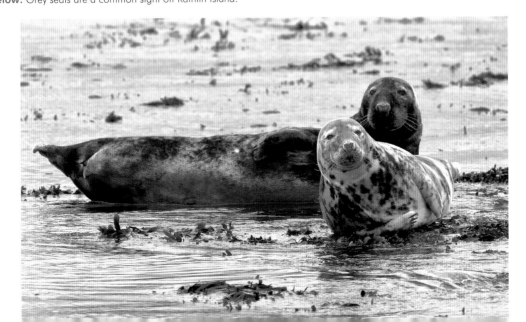

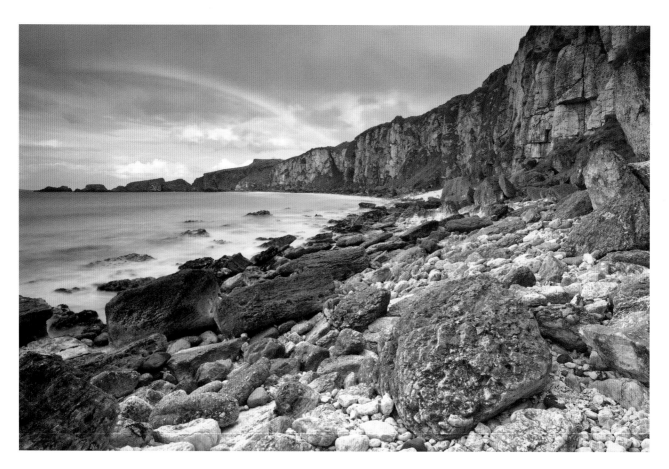

Above: Coastline at Carrick-a-Rede.

Carrick-a-Rede Rope Bridge

The rope bridge was once a necessary peril, first used by fishermen in the 1700s to cross the 65 feet/almost 20 metres from the mainland to their salmon nets on Carrick Island. Now visitors come for the views across to Rathlin Island and beyond to Scotland, and for the thrill of making the walk across the bridge, with a drop of 100 feet/30 metres to the sea and rocks below.

The Giant's Causeway

The Giant's Causeway is, perhaps, the jewel in this coast's crown, and is renowned worldwide.

This is a display of nature's strange geometry, sheltered by high cliffs and lapped and crashed by the Atlantic. There are as many as 40,000 basalt columns, formed around 60 million years ago, when volcanic eruptions caused floods of molten lava. Cooling, contraction, and cracking followed, leaving a tightly packed formation of multi-sided columns of varying heights like so many organ pipes.

It is the only UNESCO World Heritage Site in Northern Ireland, and both the science and legend of the Giant's Causeway are presented in the visitor centre, from which buses run to and from the columns on the coast. As well as being served by road, a steam locomotive runs along the narrow-gauge railway between Bushmills and the Giant's Causeway, on the old tram route.

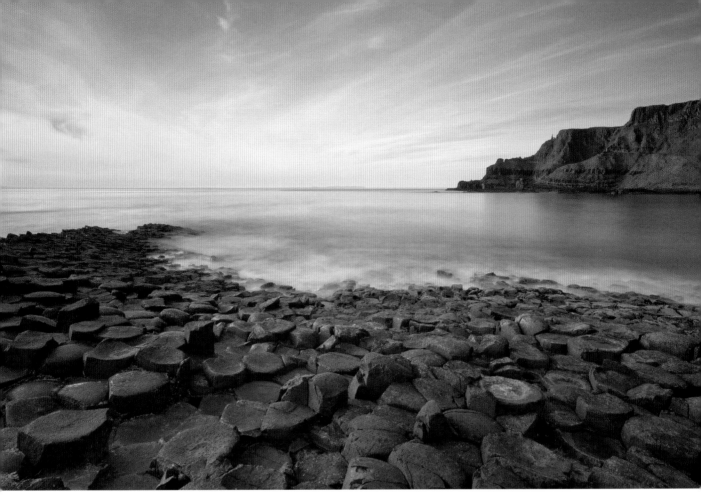

Above and right: The Giant's Causeway.

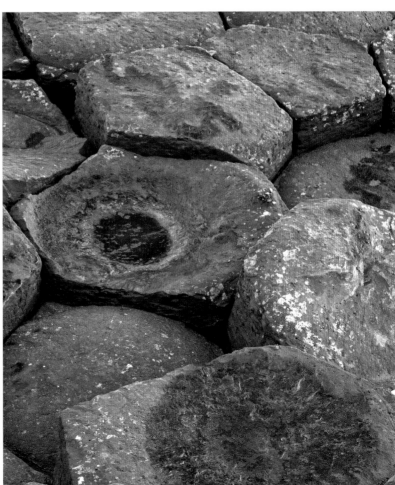

Old Bushmills Distillery

Whiskey has been produced here since 1608, when King James I granted Sir Thomas Phillips a licence to distil. Tours of the distillery, in the town of Bushmills, offer visitors the chance to learn about how the whiskey is made, as well as how it tastes.

Alongside the centuries-old Bushmills, new distilleries, as well as craft breweries, are springing up the length and breadth of Ulster.

Dunluce Castle

Fought over for decades, Dunluce Castle was finally taken and held by Sorley Boy MacDonnell in the years following his victory at the Battle of Orla in 1565. But peace paid only brief visits to Dunluce. The town that Randal MacDonnell built outside the walls was burned to the ground following the rebellion of 1641 and, in 1642, General Munro and his army ransacked the castle itself. It was finally abandoned after the defeat of James II in 1690. Said to be haunted by the ghost of a hanged English captain, Dunluce Castle and the surrounding area are coated in lore. Local legend holds that a nearby graveyard contains the remains of hundreds of sailors of the Spanish Armada, killed in the wreck of *La Girona*.

Above: All good things come to those who wait at Old Bushmills Distillery. **Below:** The ruins of Dunluce Castle challenge the Atlantic, daring invasion from the top of formidable cliffs.

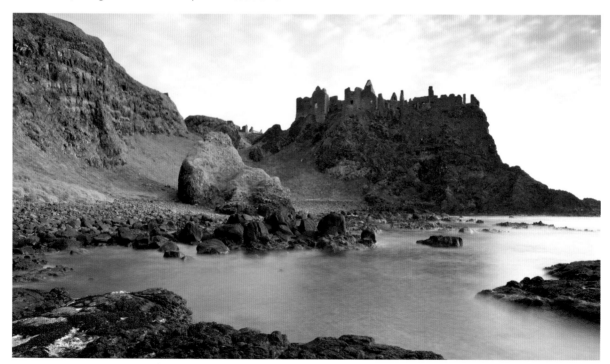

Portrush and Portstewart

Just as they have done for years, the people of Northern Ireland continue to flock to Portrush and Portstewart. Although only 4 miles or just over 6 kilometres apart, each of these seaside towns has its own personality. Portstewart, with its Dominican College (formerly Rock Castle) looming over the promenade, has a certain charming reserve, while Portrush comes alive in holiday season. Both have beautiful, invigorating beaches, offer a range of watersports, and lie close to some of Ireland's best links golf courses, including the magnificent Royal Portrush Golf Club.

Mountsandel

The Mesolithic site at Mountsandel, south of Coleraine, is the earliest known human settlement on the island of Ireland, dating back to around 7000BC. It is thought early humans settled here because of its proximity to the River Bann, and the opportunities to catch the many fish with which it teemed. A walk passes from the remains of the earthen Iron Age fort through Mountsandel Forest to the Bann, where it is common to see swans, herons, and kingfishers.

Above: Early-morning quiet on the promenade at Portrush. **Below:** Portrush beach.

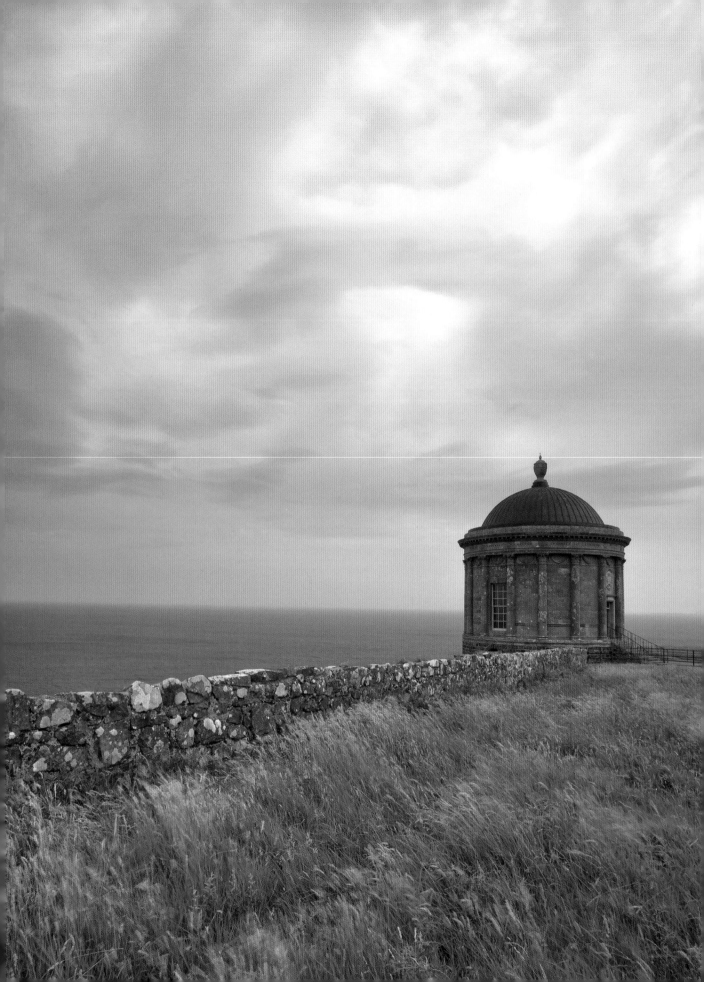

Mussenden Temple, Downhill Demesne, and Hezlett House

Mussenden Temple clings gamely to the clifftop high above Castlerock Beach and Downhill Strand. Built in 1785 as a summer library by Frederick Hervey, Earl Bishop (a name taken from his twin titles of Earl of Bristol and Bishop of Derry), and inspired by the Tivoli Temple of Vesta, it looks out across the Atlantic and back towards the ruins of Downhill House. The temple and the mansion sit within the Downhill Demesne, which offers both dramatic clifftop walks and more cultivated strolls through The Black Glen and the Bog Garden, and the chance to explore the delightful remains of the Earl Bishop's architectural vision. Close by is Hezlett House, one of the oldest domestic dwellings in Northern Ireland. Like Downhill Demesne, this thatched cottage is owned by the National Trust. Exhibits tell the story of the house and its inhabitants, and also include the Downhill Marbles, acquired by Frederick Hervey on one of his trips to Italy.

Martello Tower, Magilligan

From the late 1790s to 1815, the Napoleonic Wars raged throughout Europe and beyond. Although Admiral Lord Nelson's victory at Trafalgar in 1805 put paid to Napoleon's hopes of invading England, the shores of Britain and Ireland remained vulnerable to attack, and the construction of a coastal defence system – the Martello Towers – was ordered. One of Ireland's finest examples of these forts guards the entrance to Lough Foyle, on Magilligan Point. 'Living history' days show what life was like in the tower for its garrison of troops. The tower stands within Magilligan Point Nature Reserve, one of the biggest sand dune systems in Britain and Ireland, and home to an abundance of mosses, lichens, grasses, wildflowers, butterflies, and rare moths.

Opposite: *'Tis pleasant, safely to behold, from shore, the rolling ship and hear the tempest roar.* (From an inscription on Mussenden Temple.) **Below:** Lichens abound on the rocks around the Causeway coast.

By Rail

The railway journey between Derry-Londonderry and Coleraine is renowned for its beauty and variety. At one end, the River Foyle expands into its broad, sometimes mournful lough, while, at the other, sailboats bob on the Bann as it flows through Coleraine. Between the two, the gentle lowlands around Bellarena fall under the shadow of the towering plateau of Binevenagh, and long, empty beaches greet powerful waves before and after the train is swallowed by tunnels blasted through fierce cliffs.

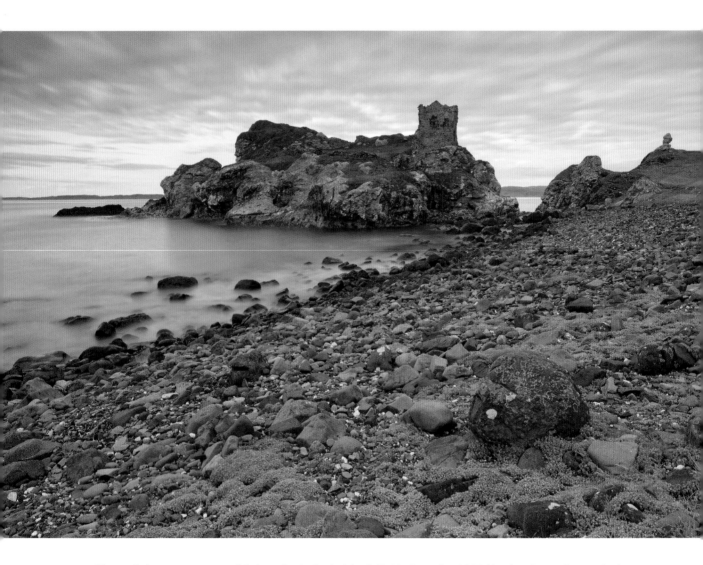

Above: Only ruins now remain of Kinbane Castle, first built by Colla MacDonnell in 1547. Nearby is Lag na Sassenach, the Hollow of the English, where English troops in the later 1500s were trapped and massacred as they attempted to take the castle. **Opposite:** Elephant Rock at Ballintoy.

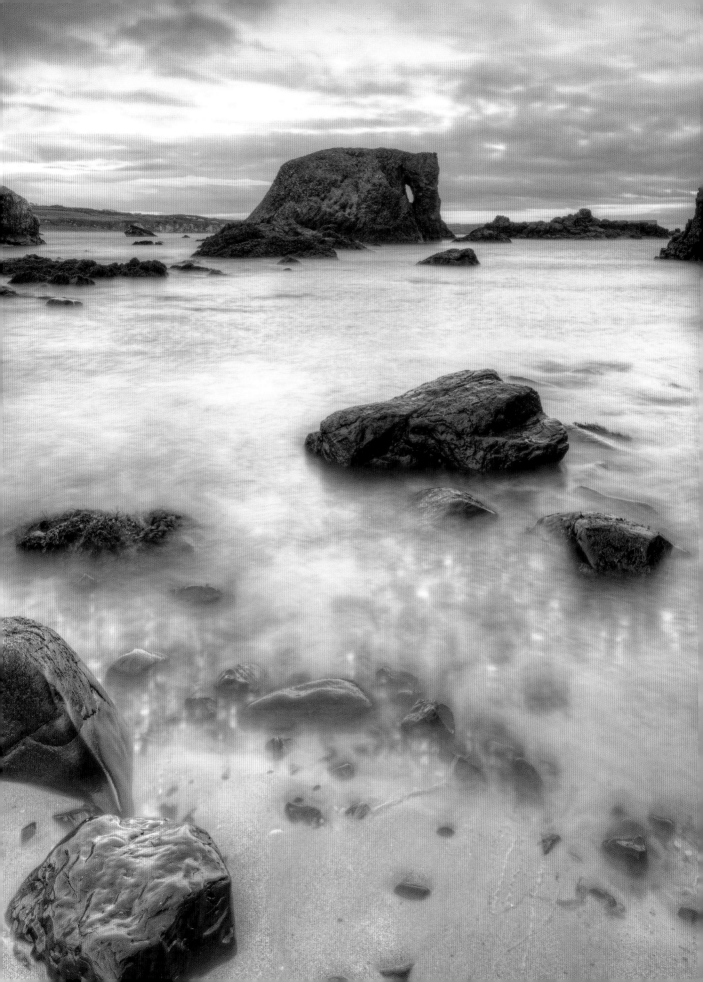

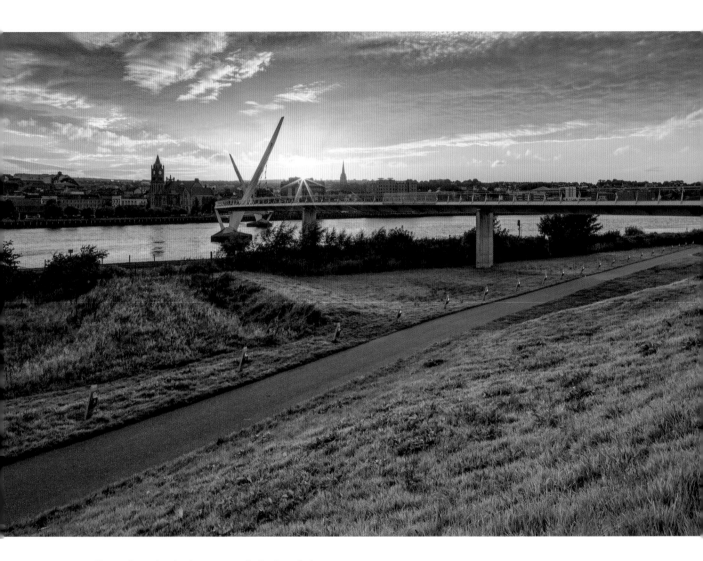

Above: Derry-Londonderry sits astride the River Foyle.

DERRY-LONDONDERRY AND INISHOWEN

According to legend, St Colmcille founded a monastery on the banks of the River Foyle in the 6th century, naming the settlement Daire, or Doire, the Irish for oak grove. In time, that became Derry. In 1613 the city was renamed Londonderry, by royal charter of James I of England, and that has been a source of contention for some ever since. Often referred to as Derry-Londonderry, many people in the city are happy to say Derry, if only for the sake of brevity.

In 2013 Derry-Londonderry, a city full of poets, artists, singers, and musicians, celebrated its year as UK City of Culture, playing host to the All-Ireland Fleadh, celebrating Irish culture, and the Turner Prize.

Water and Stone

Derry-Londonderry is a walled city, and the walls and the River Foyle are two of its defining features – physically, culturally, historically, and strategically. To the west of the river lies the Cityside and to the east, the Waterside.

Derry-Londonderry remains the only city in Ireland able to boast the complete survival of its 17th-century defensive walls. In December 1688, at a pivotal moment in Irish, British, and European history, the Jacobite army of James II, seeking to regain the throne of England from William and Mary, arrived to find entry to the city barred. As many as 30,000 people were crammed within the walls as Derry-Londonderry became a place of Protestant resistance to the Catholic James. Conditions in the city grew worse with each passing month, until the boom laid across the river by James's soldiers was broken by the merchant ship the *Mountjoy*, and the siege was lifted.

Below: Derry-Londonderry's walls dominate the city and have shaped its character through the centuries.

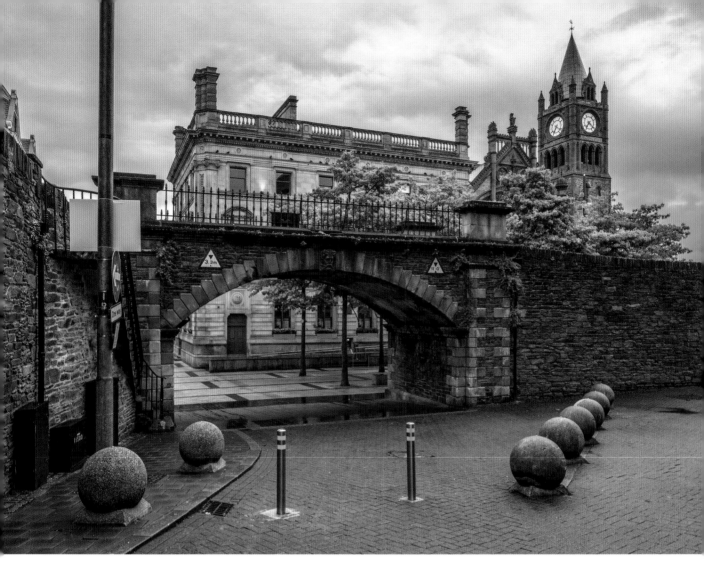

Above: *Magazine Gate, between the Tower Museum and the Guildhall.*

Roaring Meg, one of the cannon used in the city's defence, still stands on the walls, and many relics of the siege, including the hollow cannonball which contained the terms of surrender, are housed in St Columb's Cathedral. It was from close to the cathedral that James II himself was fired upon, and it was Ferryquay Gate that was locked shut by 13 apprentice boys, preventing the Jacobite army from entering the city. The lifting of the siege is commemorated each August with the Apprentice Boys' Parade. The Siege Museum and Visitors Centre, alongside the Apprentice Boys Memorial Hall, has a permanent display of the history of the siege.

The River Foyle has played a vital role in Derry-Londonderry's economic development. A thriving linen industry grew here during the 19th century. Many emigrants, especially during the Irish Famine of the 1840s, made the city their point of embarkation.

During World War Two, the strategic significance of Derry-Londonderry's location saw it feature heavily in the Battle of the Atlantic. As many as 48,000 Allied service personnel were based here, and the Foyle saw the surrender of many of the German U-boat fleet.

The remains of a ship of an altogether different fleet are housed in the Tower Museum. As well as telling the city's history, the museum keeps items salvaged from the wreck of *La Trinidad Valencera*, from the Spanish Armada, which sank in Kinnagoe Bay in Donegal in 1588, and was found by local divers nearly 400 years later.

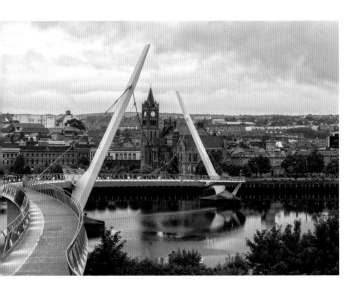
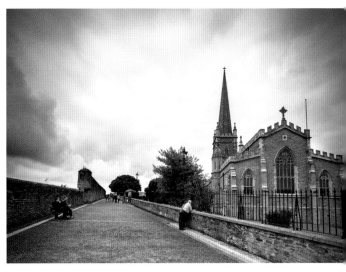

The Peace Bridge

Three bridges connect the two halves of Derry-Londonderry: the Craigavon Bridge, the Foyle Bridge, and the Peace Bridge. Opened in 2011, the Peace Bridge is a pedestrian bridge that snakes over the water, with two angled pillars slanting skywards. It has fast become a symbol of the city, not just for its elegant, serpentine form, but also for its intended unifying role. At one end of the bridge stands Ebrington Square, a former military barracks now a performing space, which is part of Derry-Londonderry's regeneration. At the other is the Guildhall, the civic centre built in 1890, where many of the city's treasures are kept.

The City's Churches

Three of the city's most historic places of worship lie on, or just within, the walls. St Augustine's stands on the original site of Colmcille's ancient monastery – the 'Black Church'. This tranquil church was favoured by those who came to the city in the Plantation.

Down the walls, towards the river, is the restored, 18th-century First Derry Presbyterian Church. The adjoining Blue Coat School Visitor Centre tells the story of Presbyterianism in the city.

Dominating the walls, and visible from far beyond the city, is St Columb's Cathedral. Completed in 1633, this cathedral was the first to be built in Britain and Ireland by the Anglican Church after the Reformation. During the siege, lead was stripped from its tower and used for ammunition. Civic documents and artefacts are held within the cathedral, while without may be found the graves of many who did not survive the siege.

Top left: The Peace Bridge, framing the Guildhall.
Top right: St Columb's Cathedral. The inscription on the dedication stone inside the cathedral begins with the words, *If stones could speake* … There is much the stones in the walls could say of Derry-Londonderry's troubled history.

Just outside the walls stands the 'Long Tower' Church, on the fringes of the Bogside. The city's first Catholic church to be built after the Reformation, in 1784, its stained-glass windows and paintings depict the stories of St Colmcille's early monastery. Around 90 years after the Long Tower was built, the sacred dedication of the city's Catholic cathedral, St Eugene's, close by in Francis Street, was celebrated.

Without these Walls

On 5 October 1968, a Civil Rights march from the Bogside was blocked by police armed with batons. Violent skirmishes followed. The following year, three days of confrontations that became known as the Battle of the Bogside saw the British army deployed on Derry-Londonderry's streets. A new century would dawn before the soldiers left.

One of the city's darkest days came in January 1972. Bloody Sunday ended with 13 civilians shot dead by troops.

Derry-Londonderry's experiences of the Troubles are shown on the Bogside murals, and at Free Derry Corner, and at the Museum of Free Derry, which tells the story of the city between 1968 and 1972, covering the demand for civil rights, the Battle of the Bogside, and Bloody Sunday.

On the fringes of the Cityside is Creggan Country Park, an activity centre offering angling and a range of watersports, while, on the Waterside, on the banks of the Foyle, is the Riverwatch Visitor Centre and Aquarium, with its tanks of lobster, crab, starfish, and freshwater fish, and opportunities to explore the river and its wildlife.

Below: Fireworks over the Derry-Londonderry cityscape.

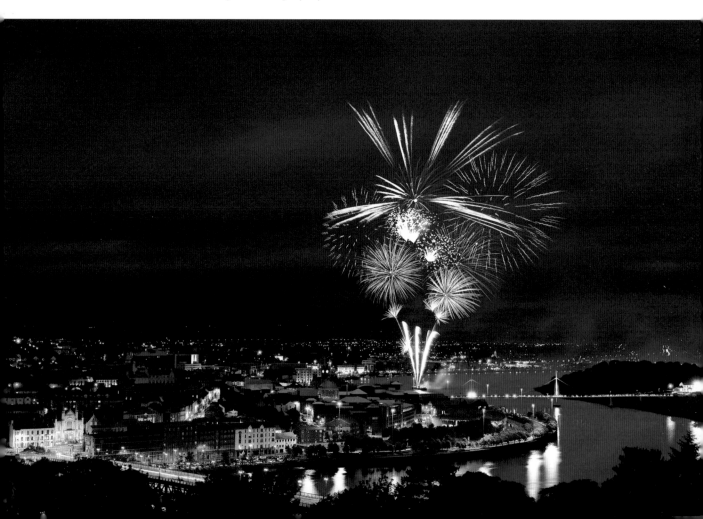

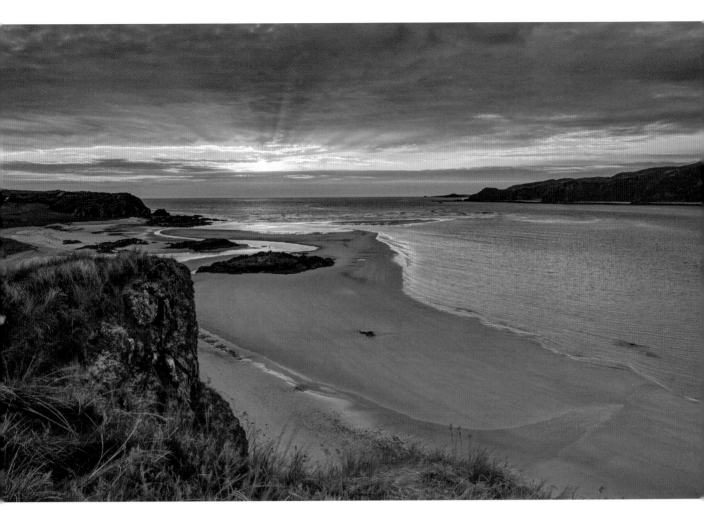

Above: Trawbreaga, Doagh Island, County Donegal.

INISHOWEN

The coastline of the Inishowen Peninsula winds its way north-east from the city of Derry-Londonderry before turning first west and then south down to Fahan and Burnfoot.

With Malin Head – mainland Ireland's most northerly point – at its tip, and Grianán of Aileach at its base, it is the island's largest peninsula.

A land of gentle drama, turbulent history, soft beaches, and ancient worship, it is contained within the waters of Lough Swilly, Lough Foyle, and the Atlantic Ocean.

So named due to its approximate length in miles, the Inishowen 100 is perhaps the best road route to follow in order to experience the region in one sweep. It opens and narrows and bends and straightens its way around the peninsula, across high moors, between steep-sided hills scored by impossible stone walls, past fields of deep, dark peat and meadows of the richest greens, all the while never far from the waters that define the land. But while Inishowen can be taken in a long, single journey, the temptations to stray from the route and reasons to linger are many. There are clean, secluded beaches, and opportunities for sailing, sea kayaking, golf, deep-sea and shore fishing, surfing, and horse-riding at points throughout the area. It is a popular destination for cyclists and bird-watchers, while whales, dolphins, and basking sharks may all be seen close to its shores.

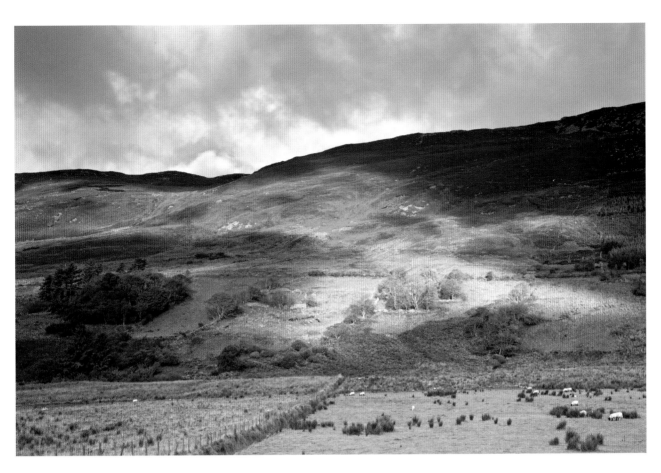

Above: Urris Hills, Inishowen Peninsula. **Below:** Now little used as a port, Moville was once a point of embarkation for thousands of emigrants leaving Ireland for a new life in the United States. It is thought as many as 280,000 people fled the famine horrors of the 1840s via the waters of the Foyle. **Opposite:** Lough Swilly, Inishowen Peninsula.

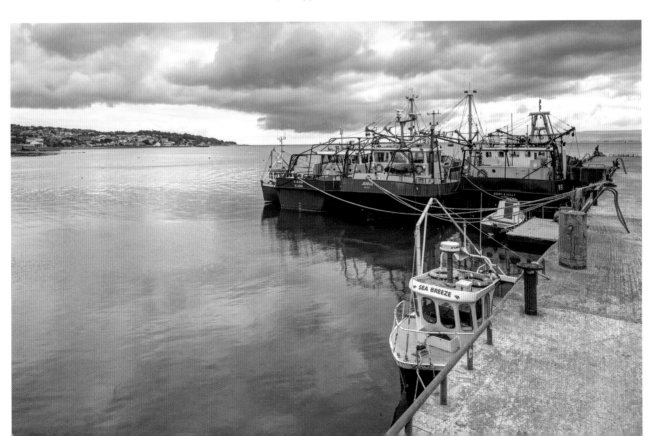

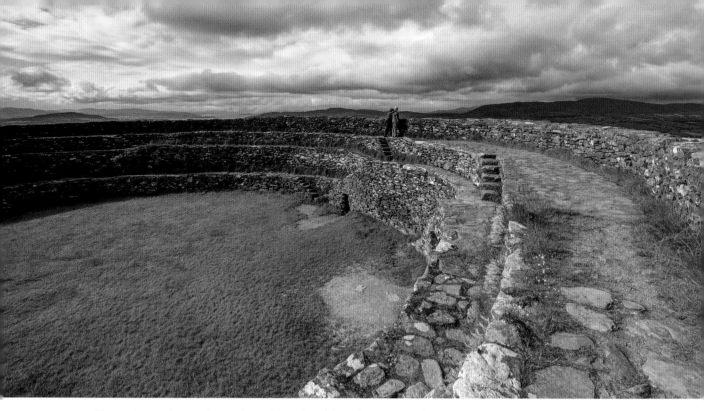

Above: A sentinel sitting close to the southern edge of the Inishowen Peninsula, An Grianán commands views over the counties of Derry-Londonderry and Donegal, and beyond to Tyrone. Wind-tough heathers cling to the hill as it tumbles down to flat, neat farm fields vying with the low waters of Lough Swilly to the west.

Grianán of Aileach

Sited on a hill around 800 feet/240 metres above the hamlet of Burt, on the road between Bridgend and Letterkenny, this stone enclosure – a cashel or ringfort – was the royal seat of the northern Uí Neill from possibly as early as the 5th century AD until some time in the 12th century. It is believed a fort has stood on this site since around 500BC. Prior to that, it is likely to have been a sacred burial ground, which may date as far back as 3000BC.

Every 21 June people gather at An Grianán to greet the dawn and to celebrate the summer solstice.

Worship, Ancient and Modern

Close to Culdaff are the Bocan Stone Circle and the Temple of Deen, both possibly dating to as far back as 3000BC.

The impact of Christianity throughout the ages is evident. Cooley Cross, near Moville, marks the site where, it is believed, St Patrick founded a church in AD442, while tradition has it that Carrowmore High Cross, on the main road between Moville and Carndonagh, is all that is left of a monastery also founded by Patrick.

Outside Culdaff is Cloncha High Cross, one of Inishowen's most important Christian sites. More recently, in the 1960s, Derry-Londonderry architect Liam McCormick designed two modernist gems, St Aengus, in Burt, and Our Lady Star of the Sea, in Desertegney, both replacing post-penal churches.

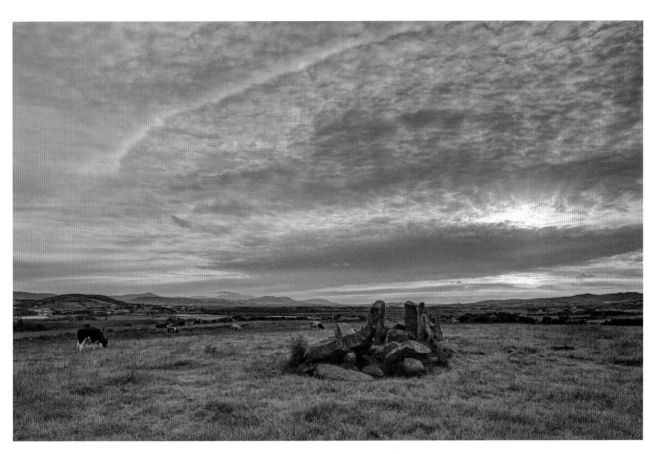

Above: Temple of Deen. **Below:** Carndonagh Church, the site of the Donagh Cross that dates from the 7th century and is considered one of Ireland's finest carved monuments from such times.

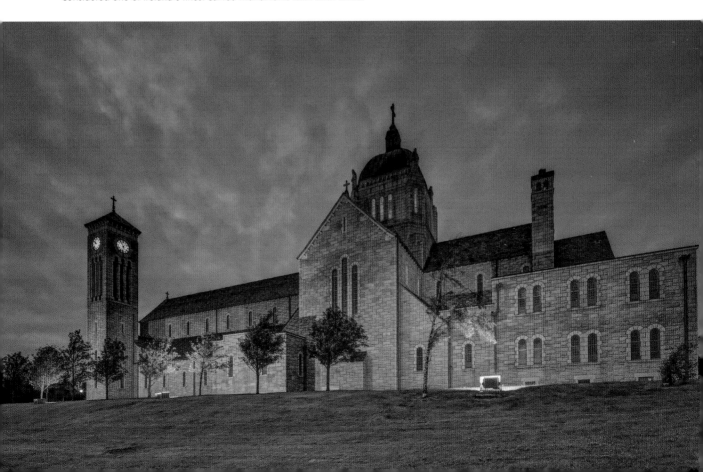

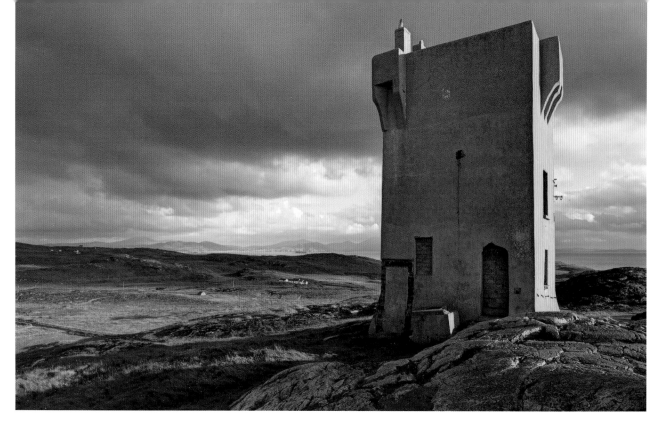

Above: Malin Head with a tower known locally as 'Banba's Tower' (Banba is an Irish mythological goddess). Built in 1805 as a Napoleonic look-out tower, in the early 20th century the tower served as the most northerly Marconi signal station for Lloyd's.
Below: Malin Head, the most northerly point on the island.

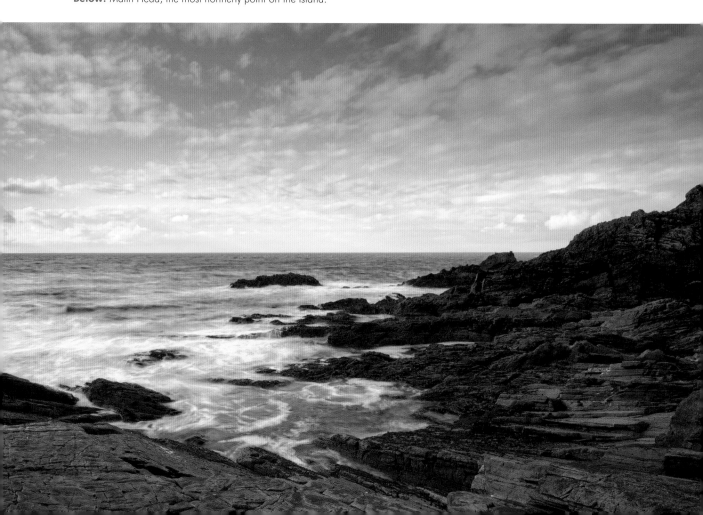

Above: Close to Ballyliffin, on Doagh Island, Doagh Famine Village offers a glimpse of life in Donegal from famine times right up to the present day. Recreations and exhibitions depict a Mass rock, hedge school, a Republican safe house, and an Orange Hall.

Malin Head

At the peninsula's peak is Malin Head, butting into the Atlantic waves and swept by constant winds. One of more than 80 lookout posts built during World War Two stands on the site. Nowadays, the watch is kept for dolphins or sharks, or the Northern Lights, rather than hostile forces.

Fort Dunree

The fort was built by the British to guard against the threat of invasion by Napoleon's forces. A Treaty Port, controlled by Britain after Irish independence, it was handed over to the Irish Republic in 1938. The area around the fort, and the waters and shores of the Swilly itself, are soaked in history. It was close to this spot that United Irishman Wolfe Tone was brought ashore after his capture aboard a ship of the French Navy in 1798. Fifty years earlier, slave trader John Newton's ship, all but wrecked by a vicious Atlantic storm, found safety in the lough. Converted by his brush with death, Newton turned away from his former life and wrote the hymn 'Amazing Grace' to mark his spiritual salvation.

Below: Beside Fort Dunree, the old, empty army camp illustrates the basic realities of service life at Dunree.

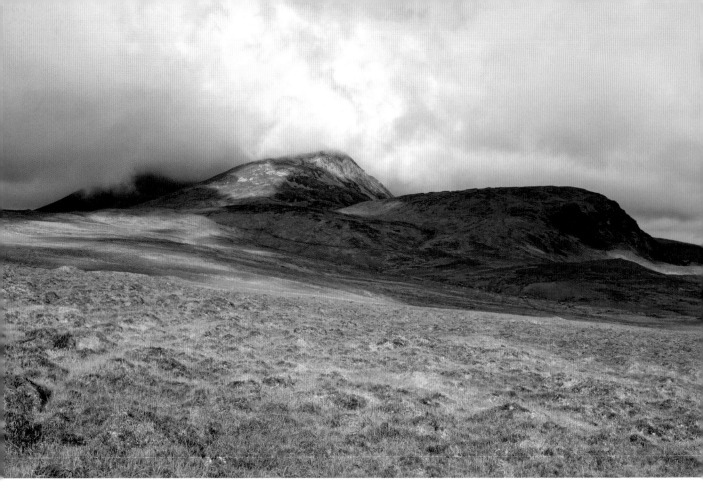

Above: Derryveagh Mountains, County Donegal. **Below:** Fanad Lighthouse.

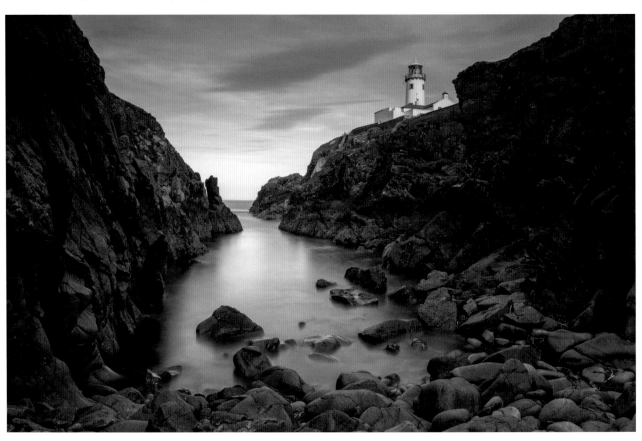

WILD NORTH-WEST DONEGAL AND SOUTH-WEST DONEGAL

This corner of Ireland, north beyond a line drawn between Dungloe and Letterkenny, is both wild and hospitable, a place to escape to, somewhere to find space, convinced you have stumbled upon a secret no one else knows.

The Fanad Peninsula

North of Letterkenny is the beautiful town of Ramelton (Rathmelton), on the Fanad Peninsula, squeezed between Lough Swilly and Mulroy Bay. With its Georgian houses and stone warehouses facing on to the quiet waters at the mouth of the River Lennon, Ramelton was once an important port, as well as Donegal's prime centre of linen bleaching. Further north is Rathmullan, another elegant town which belies the wildness of the country to come. The town's charm belies too its sad place in Ireland's history. The story of the 1607 Flight of the Earls, when Hugh O'Neill and Rory O'Donnell were forced to leave Ireland, following the Nine Years' War, is told in the heritage centre, housed in an old British gun battery on the Swilly's shores.

 The stunning drive north follows the coast, past Knockalla Mountain and Ballymastocker Beach, through Portsalon and Fanad, up to Fanad Head. Dizzying and disorienting, stretches of water appear unexpectedly to left and right until the road comes to Milford, the western base of the peninsula, and the wild north-west opens up.

Below: Rathmullan Strand, Lough Swilly.

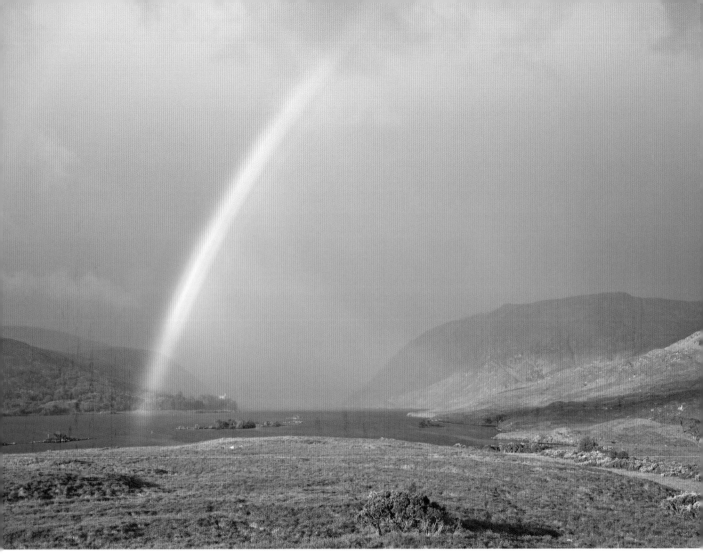

Above: A rainbow over Glenveagh National Park, where alpine plants hold fast to rocky outcrops, stretching forests shelter mosses and ferns, and heathers seek drier soil away from the bogland. Falcons, ravens, badgers, red deer, plovers, pipits, wood warblers, hares, and foxes are just some of the creatures that call this place home.

Glenveagh National Park

The coastline winds onwards, and it is tempting to stay with it, drawn by the sea and the deserted beaches. But the interior has majesty too, and at its heart is Glenveagh National Park. Set in the Derryveagh Mountains, the park covers a vast area of a rich and varied nature.

The Scottish Baronial style, 19th-century Glenveagh Castle is situated here, too, complete with visitor centre, and nearby is Glebe House and Gallery, former home of the artist Derek Hill, with its William Morris textiles, amazing permanent collection of art, including works by Pablo Picasso, Stanley Spencer, and Edwin Landseer, and frequent visiting exhibitions.

Mount Errigal and the Gaeltacht

Mount Errigal is one of the Seven Sisters, a range of Derryveagh peaks that includes Muckish, a slab of a mountain, flat-topped, whose shape is echoed in the form of St Michael's Church in Creeslough, another of architect Liam McCormick's masterpieces.

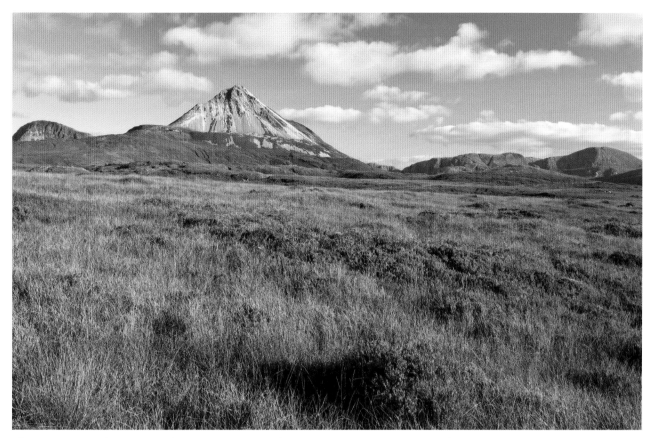

Above: Mount Errigal rises spare and imperious to the west of Glenveagh National Park, the tallest of the Derryveagh Mountains.

Below: Bloody Foreland, north-west Donegal.

Much of this north-west corner of Donegal, and reaching south to Killybegs, is within a Gael-tacht region, one of a number throughout Ireland, where Irish is the main language spoken. The preservation and promotion of the language and many other traditional aspects of Irish culture are the aim. Courses in Irish games, history, music, literature, folklore, and dance are available in Gweedore, the Rosses, Cloughaneely and other areas of the Gaeltacht.

This area has been witness to much suffering. Undeniably beautiful, much of the land is austere and difficult to work; the farmers who were driven here in past centuries struggled to survive, plagued by famine and by landlords greedy for space and money. A tapestry telling the story of the Derryveagh Evictions, when John Adair, owner of Glenveagh Castle, forced 47 families off their land, is displayed in the Colmcille Heritage Centre in Letterkenny.

The Islands of the North-west

The sea off the coast of north-west Donegal is littered with beautiful, remote, and sparsely populated islands: Arranmore, Gola Island, Inishbofin, Inishdooey, Inishbeg, and others besides. Some who live on them talk of travelling to Ireland when they leave for the mainland. Furthest from the coast is Tory Island, which can be reached by ferry from Bunbeg. Where Inishfree once attracted a commune known locally as the Screamers, for their alternative method of therapy, Tory has drawn a community of artists. Tory, which has a number of early Christian relics, including the Tau Cross, has taken its sense of independence a step further in that it elects its own king, who regularly meets visitors off the ferry.

Below: A wreck lies on Magheraclogher Beach, Bunbeg, a stark reminder of the harsh realities of life on the northern Donegal coastal fringe.

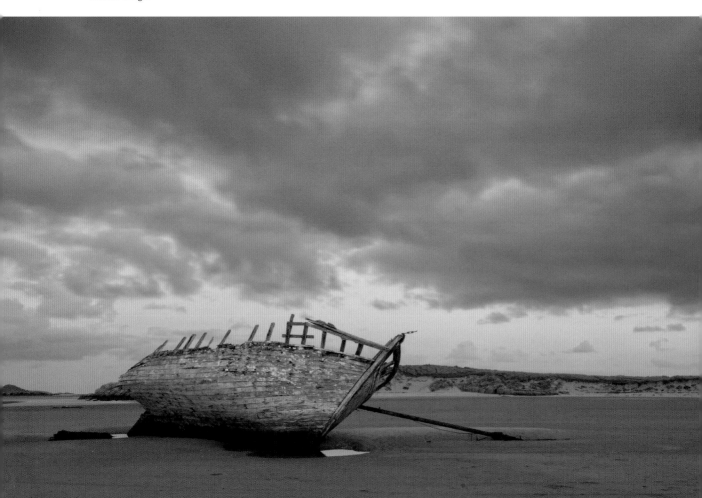

Above: Lough Derg's waters are rich in Irish Christian history. Within the lough is Station Island, where St Patrick is said to have had a vision of Hell. For centuries, and to this day still, pilgrims have made their way to the island to spend their time in retreat and in prayer in St Patrick's Basilica.

South-west Donegal

The country softens as County Donegal spreads down into the south-west. Tight, narrow roads shift into sweeping drives along wide valleys, and slalom climbs to gentle peaks. The Fintown Railway offers a jaunty trip along a 3-mile/5-kilometre stretch of the restored County Donegal Railway, on the banks of Lough Finn.

The Blue Stack Mountains shield much of this part of the county, crossed by road along the Barnesmore Gap, or by foot along the Blue Stack Way.

Below: The Blue Stack Mountains hug Lough Eske, full of trout and salmon and char.

Donegal Town

Tucked into a corner of Donegal Bay, at the mouth of the River Eske, is the town that gives its name to the county. The Irish name, *Dún na nGall*, means 'Fort of the Foreigners', after the Vikings who invaded and settled here. Easy to explore on foot, or to view from the waterbus that runs around the bay, it is a quaint and charming town, with plenty of shops selling the famous Donegal tweed, but its history has troubled passages. In the heart of the town is Donegal Castle, scene of fierce fighting between the forces of the English crown and the native Irish. Built by an O'Donnell chieftain in the 15th century, it was almost completely destroyed during the Nine Years' War, after which it was given to Basil Brooke, an English soldier, who began its reconstruction. The ruins of a Franciscan Friary, like the castle, shattered in the early 1600s, lie close to the castle. In the Diamond, in the centre of town, is the Obelisk, a monument to the men who compiled the Annals of the Four Masters, a record written in fear of the death of Irish culture, beginning with the creation of the world, and ending with the death of Hugh O'Neill, Earl of Tyrone, in 1616.

Like so many places in Ireland, Donegal town bears many scars: the Famine Graveyard lies just off the road out of town towards Ballybofey.

Killybegs

In 1588, having been harassed and chased by English ships and flogged by storms, *La Girona*, one of the surviving ships of the Spanish Armada, limped into Killybegs harbour. There, a local chieftain organised repairs, and *La Girona* left port, aiming to round Scotland and return to Spain. She got no further than the Antrim coast, where she was wrecked, with the loss of nearly 1,300 men.

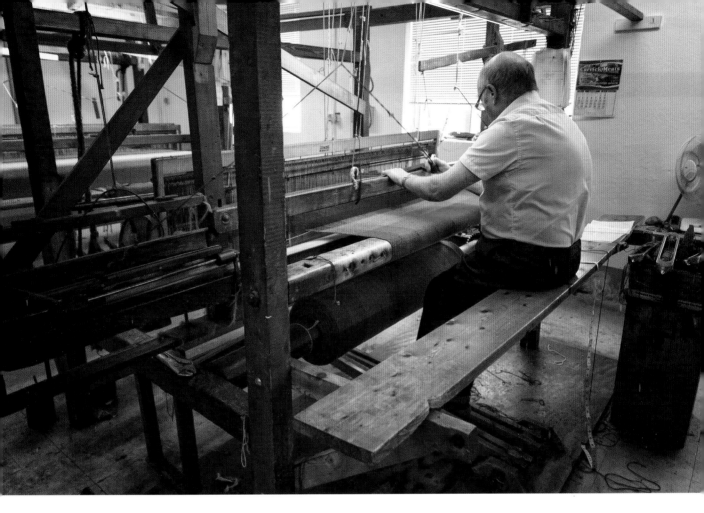

Opposite bottom: Killybegs harbour. **Above:** Studio Donegal weaving workshop, Kilcar, County Donegal.

Ships of all kinds still call into Killybegs, west along the coast from Donegal town. With its deep water harbour, it has become Ireland's leading fishing port, celebrating annually the Blessing of the Boats. The Killybegs Maritime and Heritage Centre presents the history of the port and also tells the story of Donegal carpet-making, offering the chance to work a loom. Killybegs is the home of Donegal Carpets, beautiful examples of which can be found in such places as Dublin Castle and the White House.

Slieve League

The coast runs west from Killybegs towards Slieve League, a mountain considered sacred by the many pilgrims who have scaled it. It is on the Wild Atlantic Way, and rarely will the reason for that name be more evident than here. The mountain towers over the landscape, affording views across the county and over Donegal Bay and beyond into Sligo.

The International Appalachian Trail begins here at Slieve League. While associated with the United States, the Appalachians were formed at a time when the continents of Europe and America were landlocked, and the international trail was established to recognise this. The trail runs through Donegal, into the Sperrins, and along the Causeway Coast to Larne, and can either be enjoyed in its entirety or in shorter sections, such as the Moyle Way.

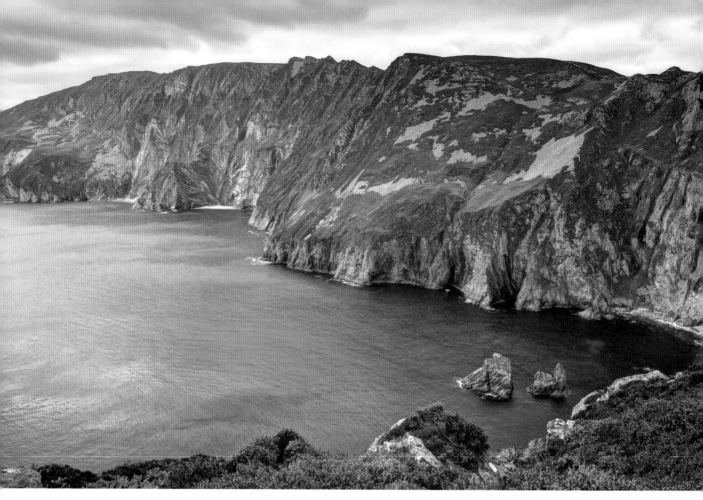

Above: The south slope of Slieve League has been shorn sheer by the elements over millennia, with the rockface pounded relentlessly and remorselessly by the ocean. **Below:** Tramore Strand, Portnoo.

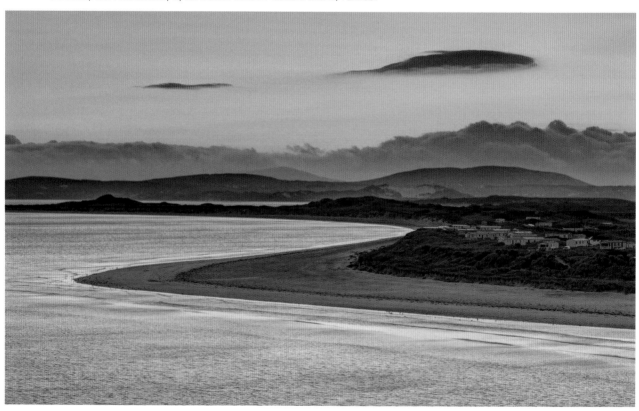

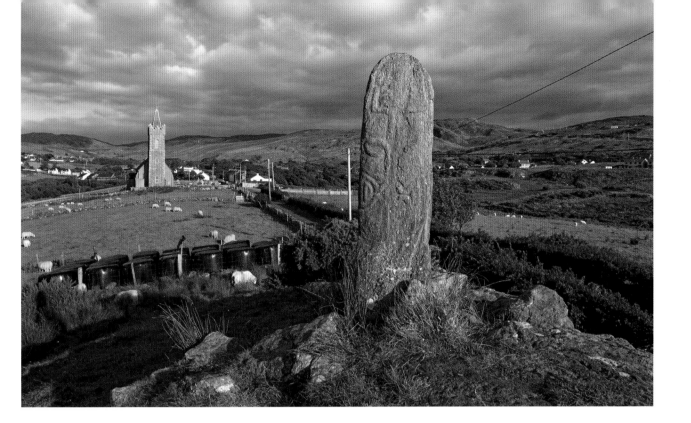

There's almost an air of secrecy about this part of County Donegal. It is not that anything is hidden; it is more that its treasures are simply waiting to be found. Even something as spectacular as the cliffs of Slieve League are not as well known as, say, the Cliffs of Moher. Around the coast – and inland too – are many villages that make perfect bases to explore and relish the little gems on offer: Clooney, Narin, Portnoo, Glenties, Ardara, Glencolmcille, and more besides. There are empty, windswept beaches, challenging golf courses, abundant rivers for fishing, and special sites such as the ring fort on an island in Lough Doon, or the dolmen north-west of Ardara, or Sheskin-more Nature Reserve, where Canadian geese spend their winters.

Above: At Glencolmcille, the land seems to expand broad and flat as it approaches the sea, with gently rising, bumpy, lumpy hills on either side. St Colmcille is said to have lived here. On the hillside above the village is St Colmcille's Chair, where he is said to have rested in contemplation, and higher beyond that is St Colmcille's Well, a spring to which people come to pray and drink. Around the spring a wall has grown, as each visitor is meant to take three stones to leave to shelter the well. **Right:** About 10 miles outside Glencolmcille, on the road to Ardara, is Port. It is a ghost village, deserted by all its inhabitants during the famine of the 1840s, its stone houses gradually crumbling.

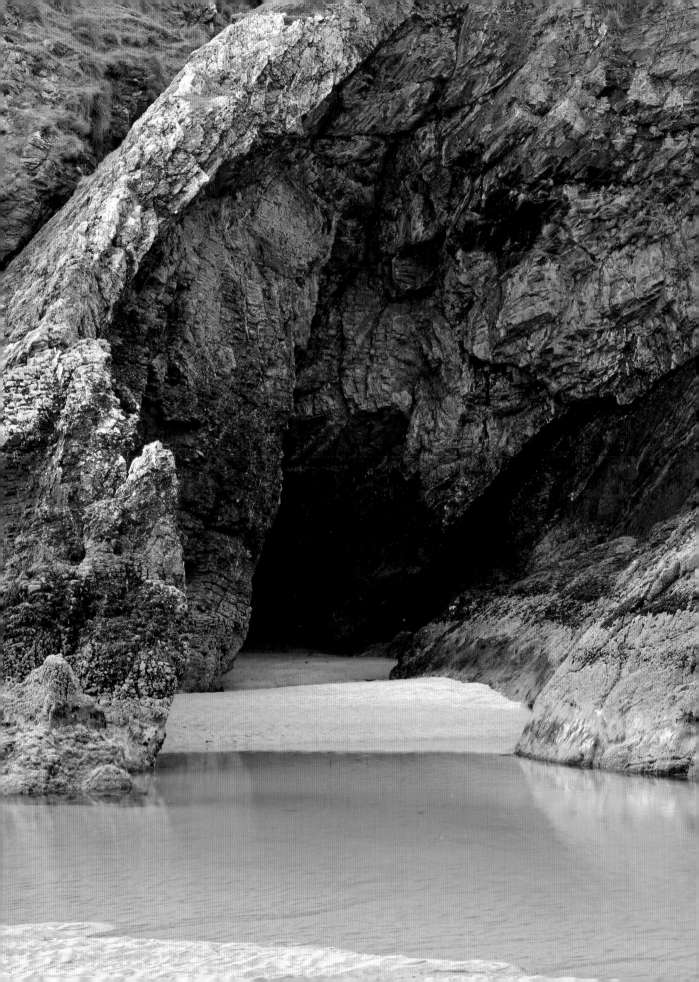

Bundoran

The mighty Benbulben across in Sligo rises over Bundoran, County Donegal's most southerly town, a seaside destination, beloved by generations. With its lovely beach, adventure park, funfair, and indoor pools for when the Atlantic breezes go beyond bracing, Bundoran is a town full of simple, old-fashioned fun.

The Rougey is a popular walking route, along the promenade, past the thrupenny pool, and up beside the grand old Great Northern Hotel, overlooking the town and its beach. It leads to the Fairy Bridges and the Wishing Chair, and ends with views of the beautiful Tullan Strand.

Bundoran is popular for horse-riding and golf, but the sport that dominates is surfing, and the stretch of Atlantic coast on which it sits attracts the world's best surfers. The Peak Reef Break in Bundoran presents a devilish challenge, while further south, Mullaghmore's huge autumnal breakers draw the daring surfer. Beginners are welcomed by the many surf schools, and Tullan Strand, Rossnowlagh, and, just south, in Sligo, Streedagh are fine beaches for those just starting out.

Surfing meets music, another of Donegal's great passions, in the annual Sea Sessions Festival, when Bundoran hosts three days of raucous and riotous fun, in and out of the water.

Opposite: Maghera Caves, Loughros, near Ardara. **Below:** Surfers' paradise in Bundoran.

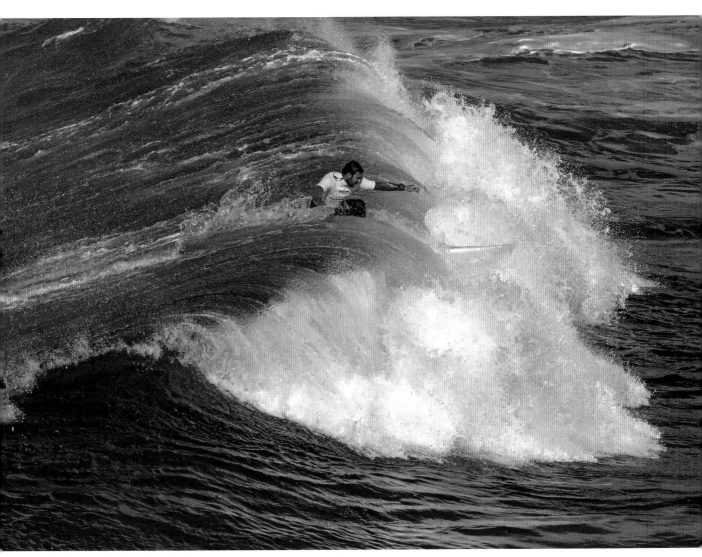

Above and below: The Sperrin Mountains. **Opposite:** Gortin Glen, Sperrin Mountains.

TYRONE, THE SPERRINS, THE LAKELANDS, AND MONAGHAN

The Sperrin Mountains cluster to the heart of County Tyrone and spread out from there, stretching east towards the closer shores of Lough Neagh and west to just beyond Strabane; looking north past Dungiven, and southwards beyond Omagh. It is one of the most extensive ranges on the entire island. The Sperrins range is dotted by loughs and coursed by rivers, providing some of the best game fishing in Europe. Its calmly undulating banks are filled with heather and deep with peat.

EXPLORING THE SPERRINS

The quiet beauty of the Sperrins can be appreciated in a variety of ways. Scenic roads wind through mountains, past forests, and over rivers. Cycle paths and mountain bike trails abound, including the 31-mile/50-kilometre Gold Cycle Route, and the area is becoming increasingly attractive to walkers. The Gortin lakes can be explored by canoe, and guided canoe trips down the Strule, Derg, and Mourne shift from white water to flat.

One of the most popular attractions is Gortin Glen Forest Park, about 6 miles/10 kilometres north of Omagh, which draws people seeking to experience the stunning views along the 5-mile/ 8-kilometre driving route, the variety of walking trails, its deer herd, and horse-riding facilities.

The Sperrins hold rich archaeological treasures and ancient sites. At Castlederg is the Druid's Altar, a portal tomb of two stones topped by a capstone. Nearby Todd's Den, another tomb, bears inscriptions written in what may be Ogham, although the only certain Ogham writing is on the Aghascrebagh Ogham Stone, close to the An Creagán centre, which houses information and exhibitions detailing the region's ancient history.

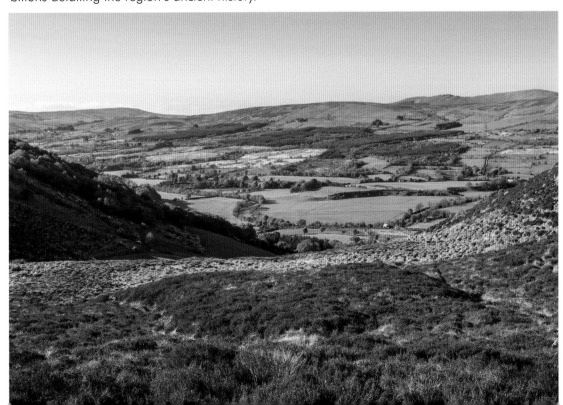

Left: Only two of the walls of Newtownstewart Castle remain, testament to the violence of the times.

Four Castles of the Sperrins

Conflict has rarely been a stranger to Ulster. The remains of four symbols of the centuries-old struggle to gain and maintain power stand in the Sperrins.

Just outside Newtownstewart, Harry Avery O'Neill's Castle is believed to date back to 1320. Built in stone – rare for the time – all that remains of the former O'Neill stronghold are its two towers.

Newtownstewart Castle sits tight inside a bend of the Strule, close to Newtownstewart itself. Following the Flight of the Earls in 1607, the O'Neill lands were taken by the English crown and distributed to supporters in the Plantation of Ulster. Sir Robert Newcomen ended up in possession of the land around Newtownstewart and immediately set about building a castle. Bought by Sir William Stewart, the castle was burned down twice, in 1641, by Phelim O'Neill, and again in 1689, by King James II, as he retreated from his failed siege of Derry-Londonderry.

Right: The ruins of Castlederg Castle stand close by a strategic ford across the River Derg. The castle is said to be haunted by a piper who, drunk one night, marched off down a supposed escape tunnel only to fall through the Castle Hole and into the River Derg.

Above: Harry Avery O'Neill's Castle, outside Newtownstewart. The Annals of the Four Masters, compiled by Franciscan monks in the 1630s, describe Harry Avery as just and noble, although there's also a story that he threatened to put to death any man who refused to marry his particularly ugly sister. Nineteen candidates opted for the noose.

West from Newtownstewart, towards Tyrone's border with Donegal, is Castlederg Castle. The town of Castlederg encapsulates much of Ulster's – and Ireland's – history. A stopping point for Christian pilgrims making for Lough Derg, here too there are ancient tombs of older worship. The recent Troubles saw the town suffer many deaths, and the lands were fought over for years by the O'Neills and the O'Donnells before they were seized in the Plantation of Ulster. Among the settlers who came from Scotland and England in the 1600s were the ancestors of Davy Crockett, hero of the Alamo. Joe Sheridan, known as the creator of Irish coffee, was born in the town.

Castle Caulfield is on the southern fringes of the Sperrins. The defensive gatehouse remains, featuring murder-holes, through which arrows could be fired and boiling oil could be poured on attackers.

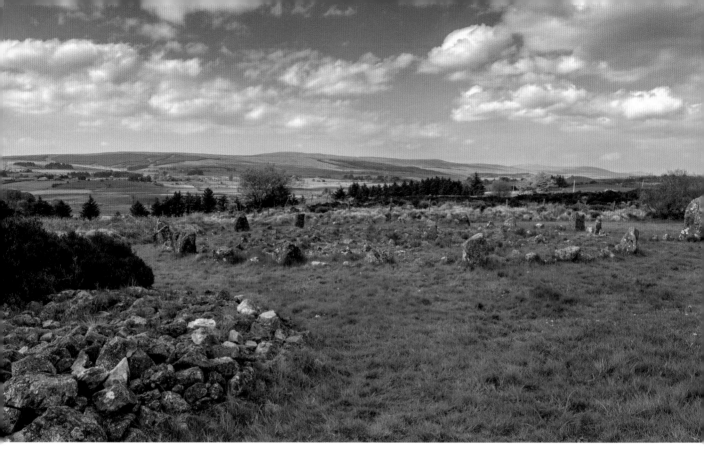

Above: Close to Cookstown is Beaghmore, possibly the finest example of a Neolithic stone circle site in a region of many.

Below: Near to where Tyrone meets Lough Neagh, there is the Ardboe Cross, evidence of the lough's deep Christian heritage. More than a thousand years old, it is over 18 feet/5.5metres high, decorated with panels depicting scenes from both the Old and New Testaments, and stands near the ruins of an abbey founded in 590 by St Coleman.

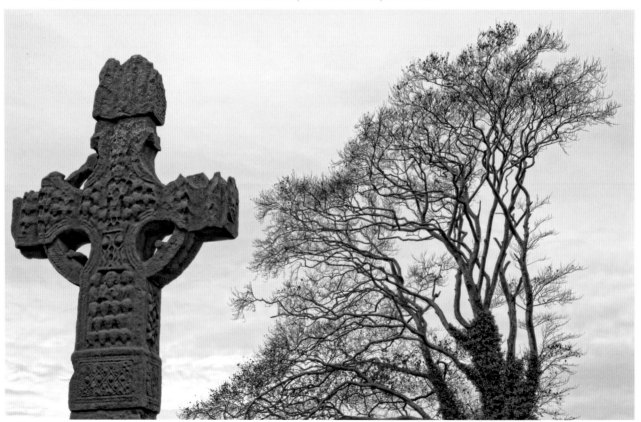

Strabane, Sion Mills, Ulster American Folk Park, Springhill House

Strabane lies on the main road between Derry-Londonderry and Omagh. One of Ireland's most famous and beloved writers was born here, and Brian O'Nolan's (Flann O'Brien) statue stands proudly in the town centre. It is not the only noted piece of public art in the town. Merrily sniffing the air outside the Alley Theatre is Ambrose the Pig. Although the sculpture's formal title is 'Where Dreams Go', the metal pig was immediately dubbed 'Ambrose', after one of O'Brien's characters, and its whirling Celtic decorations are often rubbed for good luck. Another sculpture is 'Let the Dance Begin' – five giant metal figures, affectionately known as the 'Tinnies', of dancers and musicians – created by Derry-Londonderry artist Maurice Harron, standing close to the bridge to Lifford.

South of Strabane, on the western border of the Sperrins, is the village of Sion Mills. A designated conservation area, the village boasts a rich architectural and industrial heritage. In 1835, drawn by the proximity of the fast-flowing River Mourne, the Herdman family selected the site as ideal for the construction of a linen mill. Around the mill, the Herdmans constructed a model village to house their workers and meet their physical, moral, and spiritual needs. Every effort was made to ensure the village grew and prospered in a non-sectarian atmosphere.

Continuing south from Sion Mills the road leads to the Ulster American Folk Park. This outdoor museum tells the story of emigration from the old world of Ulster to the new world of the United States. Streets and houses have been constructed to show the contrast between life in the two lands, and a full-scale model ship makes clear the conditions emigrants faced on their journey from 19th-century Ireland to new possibilities.

A contrasting glimpse into Ulster life can be found at Springhill House, to the west of Lough Neagh, between Cookstown and Magherafelt. Now owned by the National Trust, from 1680 this Plantation house was home to ten generations of the Lenox-Conyngham family. A walled garden serves the house, which sits surrounded by parkland and is home to a costume museum exhibiting a luxury and finery not afforded to many in Ulster at the time.

Below: For some 170 years Sion Mills village produced what many considered to be the finest linen in Ireland, until the mill closed in 2004.

THE LAKELANDS

The Lakelands spread over counties Fermanagh, Cavan, and Leitrim. Upper and Lower Lough Erne dominate the landscape, but nature has fractured the grand waters, creating dozens of lakes throughout the region. Many are dotted with tiny islands that have attracted those seeking seclusion and the chance to contemplate.

Inevitably, the lakes and rivers bring anglers, sailors, windsurfers, water-skiers, canoeists, and visitors wishing to cruise the waterways. But the land of the lakes is compelling, too, packed with sites demanding attention, and offering activities such as caving and cycling. And, this being Ulster, there is wildness beside the sleek and gentle green.

Marble Arch Caves Global Geopark

The beauty of the Lakelands has been recognised by UNESCO, which has established a global geopark here, to protect, manage, and sustain the landscape and sites of the region.

At the heart of the geopark are the Marble Arch Caves, an entrancing series of underground caverns and rivers, along which boats carry visitors, providing a riveting view of the chambers and rock formations. It is a shimmering, multi-sensory experience, a world away from the surface.

Cuilcagh Mountain Park is south of the caves, where the slopes of blanket bog are conserved, and, to the west, is the Cavan Burren. Expert guides lead trails through the Burren, with its glimpses into a pre-glacial world of lost rivers, sink-holes, and dolines.

Below: Lower Lough Erne, County Fermanagh.

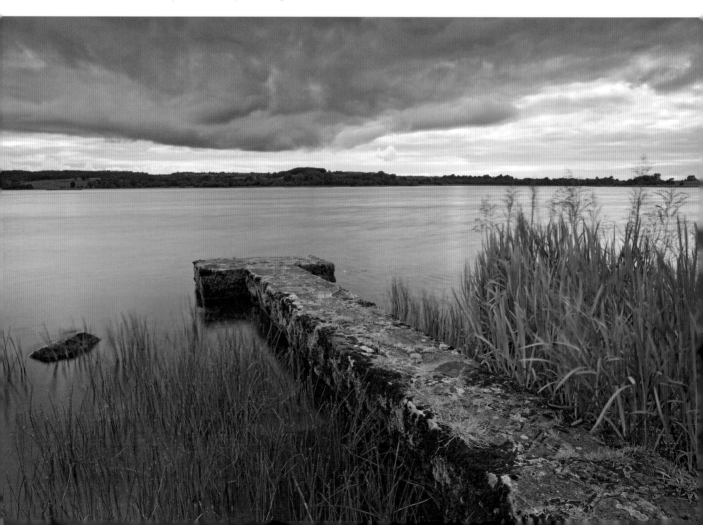

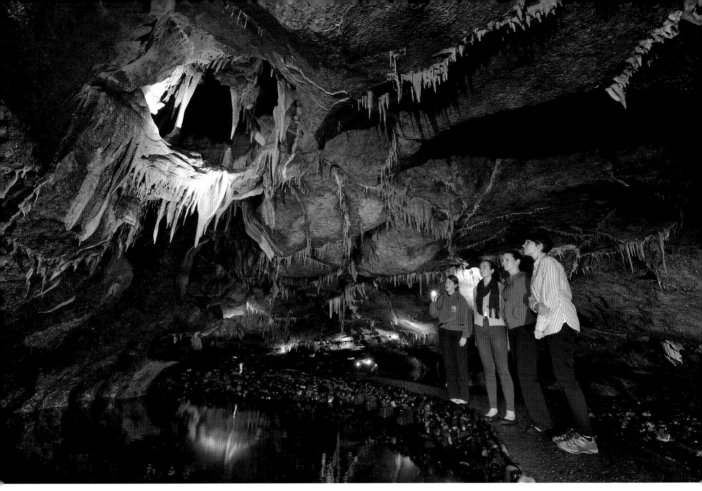

Above: A tour group admiring 'The Cradle' rock formation in the Marble Arch Caves. **Below:** The Cavan Burren, like the Marble Arch Caves, is a different world, above ground but alien, and at times chilling. It is a landscape filled with Neolithic tombs, ancient images made in rock, forts, and primitive monuments.

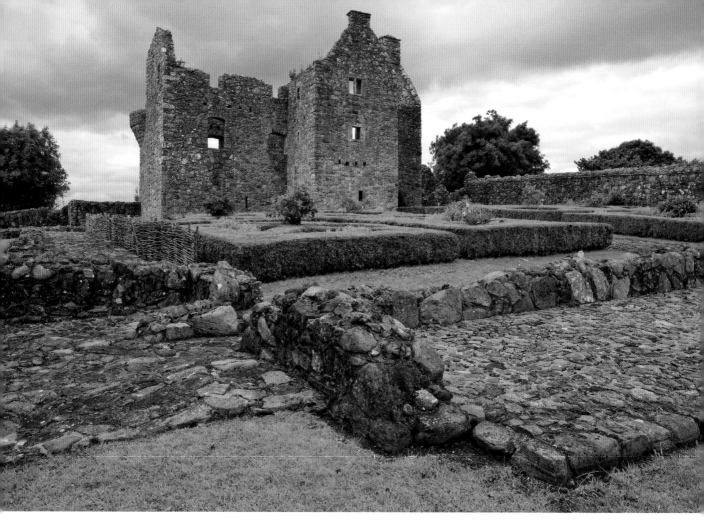

Above: On Christmas Eve during the 1641 Rebellion Tully Castle surrendered to Rory Maguire in return for safe passage for local Protestant settlers who had taken refuge within its walls. Tragically, 69 women and children and 16 men were massacred by the Maguires on Christmas Day.

Castles, Mansions, and Monasteries

The architectural heritage of the Lakelands bears comparison with any in the whole of Ireland. Moneygashel Cashel boasts three stone enclosures dating back to the early Christian period. In the same area, an ancient tomb and standing stones suggest the site had been in use long before the cashels were built.

Castles, mansions, and grand houses – both ruined and restored – punctuate the landscape. Monea Castle, Castle Balfour, and Tully Castle are three of many which date from the Plantation era, although Monea was built on the site of an earlier crannóg (a small, artificial fortified lake dwelling).

The ruins of Portora Castle stand close to where the River Erne meets the lough, just outside Enniskillen. Having survived attack in both 1641 and 1688, the castle fell at the hands of the boys of Portora Royal School, enjoying an extra-curricular gunpowder session. Castle Archdale Country Park holds many ruins, while Castle Archdale itself was a Royal Air Force base during the Second World War. On the banks of Lower Lough Erne, a squadron of flying boats was stationed here, patrolling the Atlantic, to protect convoys from German U-boats. Catalinas and Sunderlands flew through the Donegal Corridor, as part of a secret agreement between neutral Ireland and the United Kingdom.

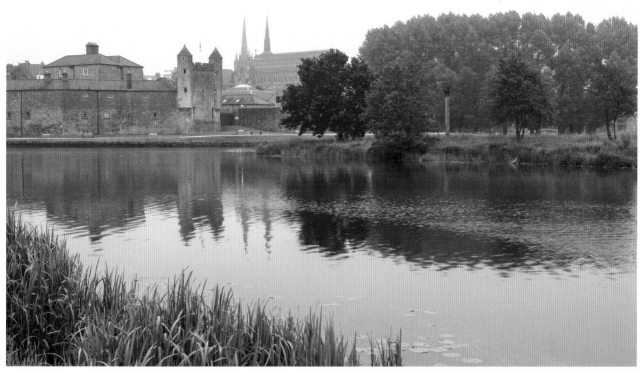

Above: Enniskillen Castle, a former Maguire stronghold and then Plantation castle and military barracks, has two museums: one which tells the story of County Fermanagh, and the Inniskillings Museum, detailing the history of the Royal Inniskilling Fusiliers and the 5th Royal Inniskilling Dragoon Guards. **Below:** Upper Lough Erne, just south of Enniskillen in County Fermanagh.

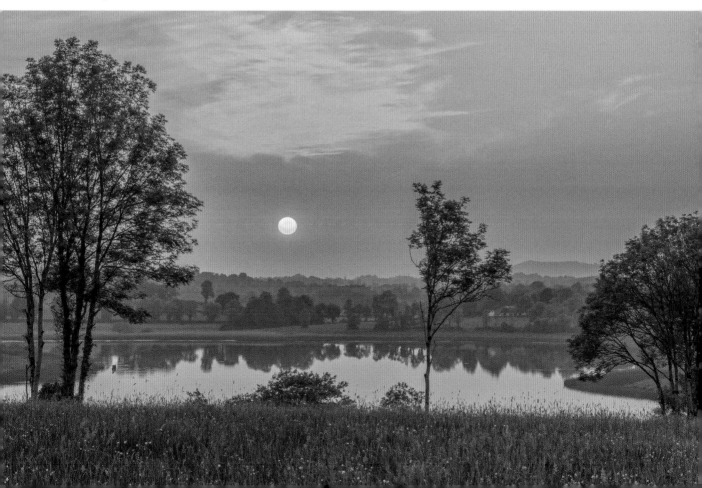

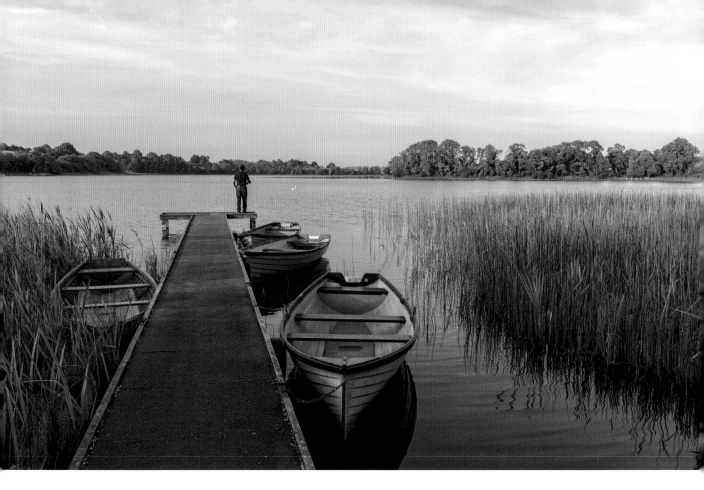

Above: A fisherman on Upper Lough Erne.

Castle Coole and Florence Court are far from the roar of battle. Magnificent and dignified, Castle Coole is a neoclassical mansion built in the later years of the 18th century for the Earl of Belmore. It sits just south-east of Enniskillen in beautiful wooded parklands. The luxuriously decorated rooms are open to visitors, who can also explore the nature of servant life downstairs.

Florence Court is on the other side of the Erne, to the south-west of Enniskillen. Like Castle Coole, it is one of Ireland's most important Georgian houses. Stately but with an emphasis on home, this amiable, welcoming mansion provides stunning views of the surrounding landscape. There is a walled garden, a summer house, and an ice house, while inside there is an impressive collection of Irish furniture.

Left: Spirituality is a feature of the Lakelands, as the many ruins of abbeys and monasteries suggest. Drumlane Abbey is a prime example. By the side of Garfinny Lough, it features a monastery perhaps built by St Colmcille in the 6th century. The centuries have been particularly kind to the round tower, standing strong in contrast to the crumbling abbey.

Belleek Pottery

John Caldwell Bloomfield inherited the Castle Caldwell estate in 1849. Determined to do something to improve the lot of his tenants, Caldwell surveyed his lands and discovered that his estate possessed all the necessary raw materials to produce pottery. His lands also included the village of Belleek, close enough to the Erne to utilise its power.

And so Belleek Pottery was born. The company became world famous for its fine, often intricately crafted porcelain, which is still produced here. The visitor centre and museum tell the story of the success of Belleek.

The Lakeland Islands

The many lakeland islands bring a sense of seclusion, refuge, and retreat to the region.

There are two enigmatic Celtic statues in Caldragh Cemetery on Boa Island. One is of two figures, one male, one female, standing back to back, one facing east, the other west. The second statue is the Lustyman – from nearby Lustymore Island – although its gender remains uncertain. Only its right eye is properly carved, and some believe it might represent the Cailleach, or Divine Hag, a deity from Celtic mythology.

Belle Isle offers more contemporary attractions. The castle has been restored and refurbished, and is now the location of a highly regarded cookery school.

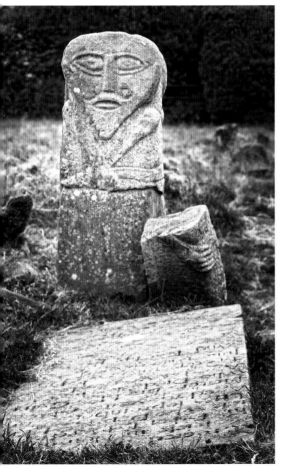

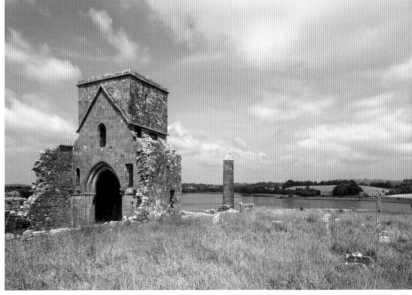

Above: Christians have worshipped on Devenish Island since the 6th century, when the monastery was founded by St Molaise. Vikings raided the island in AD837, and fire swept through the buildings some three hundred years later; through the centuries the site has seen many repairs and changes, including an intriguing 15th-century stone cross in the graveyard. **Left:** The mysterious Janus-type figures on Boa Island. **Overleaf:** The ancient Crom Yew on the beautiful Crom Estate, an important nature conservation site on the banks of Lough Erne. The 8 square kilometre/2,000 acre demesne provides peace and tranquility and is home to a stunning range of wildlife, including bats, butterflies, wild deer, pine marten, and rare lichens.

MONAGHAN

East of Fermanagh and north of Cavan is County Monaghan. It is a land of gentle scenery, offering wonderful nature walks, and full of loughs and rivers of great appeal to anglers, game and coarse alike. There's much to fascinate here as part of Ireland's Ancient East. Amid the azaleas and rhododendrons of Rossmore Forest Park, just southwest of Monaghan town, there is a wedge tomb and a court tomb, both dating to around 3000BC. In the northwest of the county, Dartrey Forest, in Rockcorry, is close to a cluster of lakes, all connected by the Dromore River, and is bordered by a Famine Wall, built by the starving in the 1840s, in return for pitifully small portions of food. Monaghan also saw an important battle in the Nine Years' War, at Clontibret, in 1595, when the forces of Hugh O'Neill defeated the English army under Sir Henry Bagenal. A stone marks the site of the battle.

Above: An idyllic spot in Rossmore Forest Park.
Opposite: Dromore River, County Monaghan.
Right: In the centre of Clones, there is a round tower and cross, part of the monastic settlement founded by St Tiernach in the early 6th century.

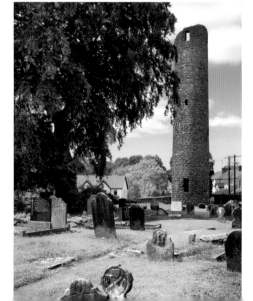

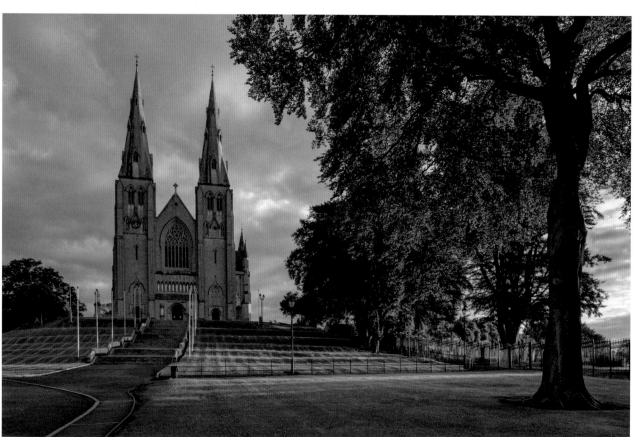

NORTH ARMAGH

While the rocky, jagged Ring of Gullion is in the south of the county, the north of Armagh has a softer, gentler beauty. Armagh, the smallest county in Northern Ireland, is the 'orchard county', where to its north the Armagh Bramley Apple is grown. It is a region rich in heritage, culture, and scenic landscapes.

Christianity in Armagh

A long-established place of learning, Armagh is the city of saints and scholars, the ecclesiastical capital of Ireland, home to both the Roman Catholic and Church of Ireland primates of the island.

Both the Catholic and the Church of Ireland cathedrals are dedicated to St Patrick, and with good reason. In 445, Patrick, having been inspired by a vision to return to Ireland, built his first stone church on a hilltop – Ard Macha – and made Armagh the seat of his church. On this same site the Church of Ireland Cathedral of St Patrick now stands. It contains fascinating features and statuary, as well as the grave of Brian Boru, High King of Ireland, buried here following his death at the Battle of Clontarf in 1014.

Work began on St Patrick's Roman Catholic Cathedral in 1840 but was stopped during the Famine of 1845–52. The cathedral was dedicated for worship in 1873. However, it was only consecrated in 1904, when work finished on the stunning interior. In recent years, an App was jointly released by the two cathedrals, allowing visitors to explore both churches and their shared history and heritage. The cathedrals are just two in a cluster of the city's stopping points along the St Patrick's Trail.

The monastic settlement which grew in Armagh became a celebrated centre of learning. Monks and theologians came from all over Europe to study here. Ferdomnach wrote the Book of Armagh in the city, in the first half of the 9th century, creating a chronicle vital to the understanding of early Irish civilisation. An exhibition dedicated to the book is on display at the St Patrick's Trian Centre, which also tells of the time Jonathan Swift, author of *Gulliver's Travels*, spent in Armagh. The reputation for learning and respect for knowledge remains intact today. Among other resources, the city boasts the Cardinal Tomás Ó Fiaich Memorial Library and Archive, a free reference library for public use holding a deep and broad range of material relating to the history, literature, language, culture, and sport of the whole island.

Opposite top: The rich land of Armagh beneath sun-pinked clouds in an evening sky. **Opposite bottom:** On a hill across the valley from the Church of Ireland cathedral sits St Patrick's Roman Catholic Cathedral, a French Gothic building with two spires.

Navan Fort

Navan Fort – Emain Macha – is an ancient Iron Age earthworks that was once one of the great royal centres of pre-Christian Ireland. In the Ulster Cycle, this is the land where Cú Chulainn and the Red Branch Knights roamed. It is a site of huge archaeological interest.

Below: A grassy mound at the Navan Fort. The Navan Centre tells the story of the place, with guides to take visitors round the earthworks, ring barrow, and other features of the fort.

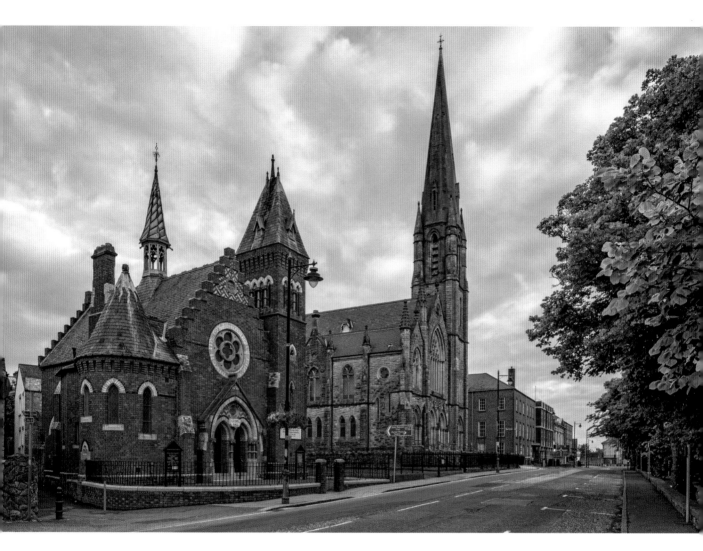

Above: The redbrick Gospel Hall was originally built as a Masonic Hall in 1884. Beside it is the 17th-century grey spire of the First Presbyterian Church.

Armagh City

Armagh is a small city, easy to explore in one sense, but bursting with sites insisting on attention. The Armagh Observatory, a listed building founded in 1789, and more recent Planetarium are both in the grounds of the Astropark, with its digital theatre, tours of the night sky, Human Orrery, and telescope domes from which the planets can be explored.

The oldest library in Northern Ireland, Armagh Public Library is also a museum, with a collection which includes a first edition of Swift's *Gulliver's Travels*, dating from 1726. Another museum, No 5 Vicars' Hill, holds further pieces from the library, including rare coins and early Christian objects. The Royal Irish Fusiliers' Museum, Armagh Gaol, the County Museum, and Milford House all provide perfect chances to linger and learn. Milford House was once owned by the McCrum family, leading linen manufacturers in Ulster. One particular McCrum, William McCrum, was a keen footballer and the first to come up with the idea of the penalty kick, in 1890.

Leaving the city, heading north towards Loughgall, are sites hugely important in Ulster's history. On 21 September, 1795, tensions between Catholics and Protestants came to a head, and a pitched battle broke out between the Catholic Defenders and the Peep o' Day Boys at a crossroads

Above: Loughgall, County Armagh, a village which witnessed The Battle of the Diamond, and today tells the story of the Orange Order in its Museum of Orange Heritage, at Sloan's House, where the order's first warrants were issued.

known locally as the Diamond. Shortly after the Battle of the Diamond, a number of Protestants gathered at Dan Winter's house, near the crossroads, and decided to form the Loyal Orange Institution of Ireland. There are tours of the 18th-century cottage, which contains relics of the battle, as well as Orange Order memorabilia.

Festivals

Armagh holds fairs, festivals, and schools throughout the year. There's a Festival of Song and a Piping Festival, and Armagh's annual Georgian Day recognises the architectural character of the county. There's a John Hewitt International Summer School in honour of the Ulster poet, and a Charles Wood Summer School which commemorates the Armagh-born composer of sacred music. The Apple Blossom Festival is held every May. Its activities focus on Loughgall's Manor Estate and Country Park, but almost every field and hillside in the north of the county will display a natural celebration of the Bramley. An App for the Bramley Apple Tour is available for download, to guide drivers and cyclists along the route showing the orchards at their finest.

There is also the Road Bowls Festival. Road Bowls is particularly popular in Armagh, although they prefer to call the bowl a bullet (a 28-ounce cast-iron spherical ball). Each contestant attempts to shift the bullet along the course taking as few throws or rolls as possible. The festival is well-attended, and competition is fierce.

The Parks and Country Houses of Armagh

There are some fine country houses and parklands in north Armagh. The Argory is a striking late-Georgian house, with two pavilions, arbours, and a delightful display of spring flowers. The table on which George V signed the Constitution of Northern Ireland is in Ardress House, which dates from the 17th century and which possesses orchards with old varieties of apple, and an Irish Rose Garden.

 South, towards Newry, is Derrymore House. A bright thatched house, built in the vernacular style, this too has a special place in Irish history, being where the Act of Union between Britain and Ireland was drafted.

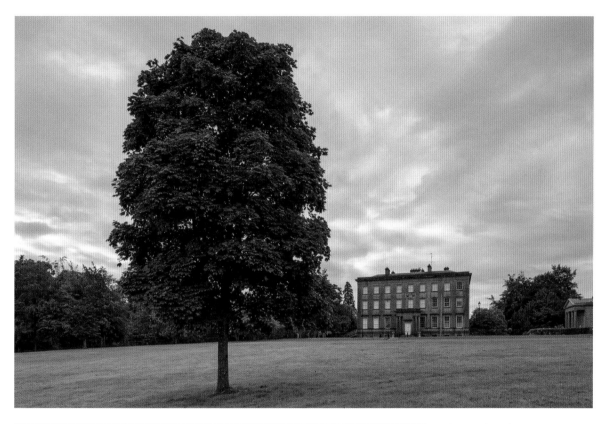

Above: The Palace Demesne in Armagh city is an absolute jewel of relaxing parkland. Former home of the Church of Ireland Archbishops of Armagh, there is the remains of a 17th-century Franciscan Friary at its entrance.

Left: Gosford Forest Park, favoured by Jonathan Swift, has deer, rare breeds of sheep, cattle, and poultry, an arboretum, and a walled garden among its attractions.

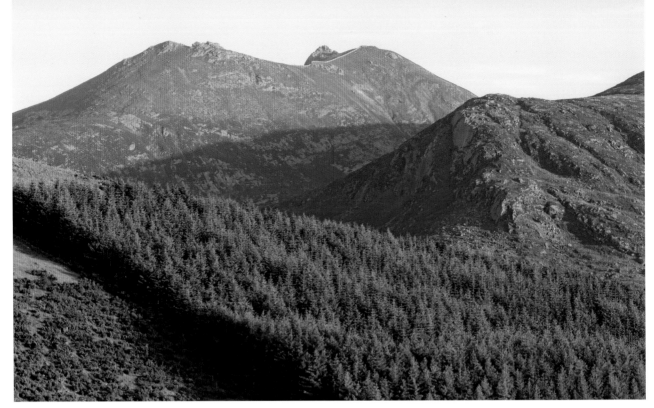

Above: Beguiling, and often winter-white-tipped, with panoramic views, Slieve Donard is the highest mountain in all Ulster. It rises above the coast at the eastern edge of the Mournes, overlooking Newcastle. At its peak are a cairn and a low stone tower.
Below: A range of trails through the Mournes invites all levels, up steep challenges or across convivial hills. A particularly popular destination within the Mournes is the Silent Valley Reservoir, ringed by the 22-mile/35-kilometre dry stone Mourne Wall.

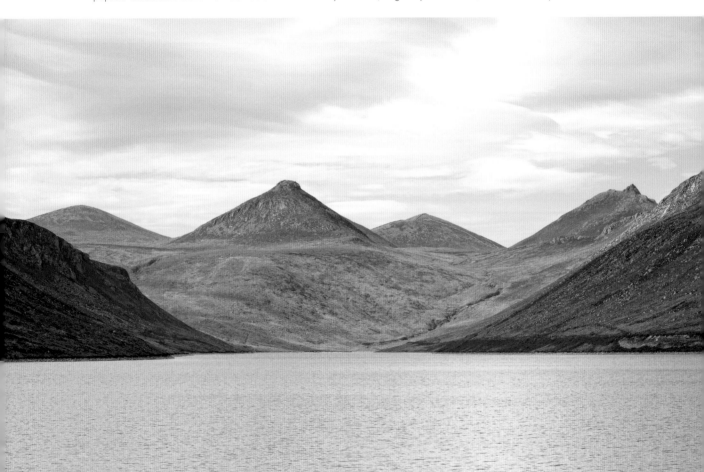

THE MOURNES AND THE RING OF GULLION

The Mourne Mountains, thought to have inspired CS Lewis as he created Narnia, spread west from the coast of South Down towards Newry and the county border. Within and around these beautiful ranges, an Area of Outstanding Natural Beauty, are fascinating ruins and ancient monuments, charming towns, bracing beaches, and pockets of gentle culture. Here too are thrills, adventure, and challenging sport.

Walkers are drawn too to the Ring of Gullion, in nearby South Armagh. The Ring of Gullion Way leads from Newry deep into the region, with an alternative route reaching the peak of Slieve Gullion. The mountain is at the heart of a ring dyke, concentric rock formations formed by volcanic activity millions of years ago. Warriors of Irish history stalked these parts, and the area is full of ancient habitats and relics, such as the court tomb at Ballymacdermot and the King's Ring at Clontygora, and the highest known passage tomb in the UK and Ireland, at the summit of Slieve Gullion.

Below: Killeavy Old Churches (pictured here), Dundrum Castle, and other sites in the Ring of Gullion show the influence of later settlers, such as the Normans.

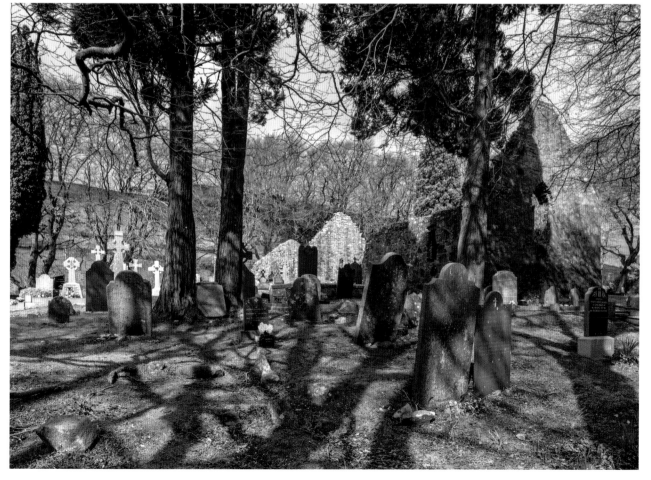

Outdoor Pursuits

A number of outdoor pursuits centres operate in the region. From seaside beaches to deep inland, a host of exciting experiences is available, such as sea kayaking, coasteering, wild swimming, canoeing, bouldering, mountain-boarding, climbing, pony-trekking, and abseiling – all guaranteed to set the pulses racing. Racing pulses can also be had by venturing a touch north to Down Royal Racecourse. There is fishing, too, both at sea and on the rivers and lakes.

Ulster is also a golfer's paradise, and players bring their clubs from all over the world to try the courses of South Down and South Armagh.

Royal County Down is a championship links course, between the Mournes and the sea. It has hosted some of the game's top players down the decades, and is one of the best courses in the world. It is, however, just one of a number of must-play courses in South Down and South Armagh.

Above: Mourne Mountains at dawn. **Below:** Carlingford Lough.

Kilkeel, designed by Eddie Hackett, sits alongside Carlingford Lough, and, like Royal County Down, has been the scene of top tournaments. Warrenpoint is another course flanked by Carlingford Lough, with the Mournes on its other side; it is a stunning parkland course, inside the Hall Estate, home to Narrow Water Castle. Cloverhill and Mayobridge are both demanding courses, while playing Ardglass is an unforgettable experience. Many of its holes line up alongside the sea, a dramatic backdrop to the challenge of the course and elements, while the clubhouse is a renovated castle, one of a number to be found in and around the old village of Ardglass.

Towns and Villages of the Mournes

The region is home to a number of attractive and historic towns and villages, many on the coast and close to tempting beaches. Newcastle is a lovely seaside town with its own lido, the Rock Pool, and miles of beaches around Dundrum Bay. Down the coast is Annalong, a quiet and pretty old port, while further south is Kilkeel, the capital of the ancient Kingdom of the Mournes.

The first ship canal in Britain and Ireland was built running through Newry, opening in 1742. Traffic no longer runs through it, but it is now highly prized by anglers for its rich stocks of pike, perch, eels, and trout. The town, which sits in the Gap of the North, is home to the Newry and Mourne Museum, housed in Bagenal's Castle. The museum recounts the story of the area, running from pre-history and covering Norman influence, the effects of the English on the area, Newry's Cistercian foundations, economic and social development, emigration, Home Rule, Partition, the impact of the new border, and the effects of the Troubles.

Below: Kilkeel is an animated town, home to the largest fishing fleet in Northern Ireland, as well as the Mourne Seafood Cookery School.

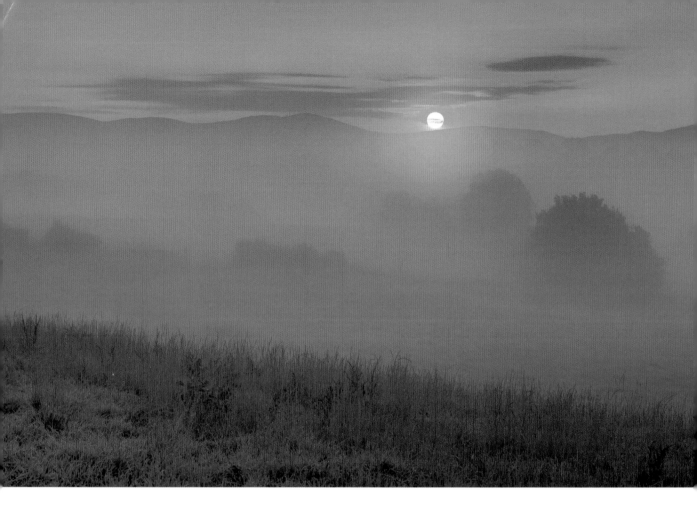

Above: Ballyroney, County Down. Patrick Brontë, father of Charlotte, Emily, and Anne, was born into a farming family in County Down on St Patrick's Day, 1777, and became a preacher at Rathfriland's Drumballyroney Church, which is now the Brontë Homeland Interpretive Centre. It is also the venue of the Brontë Music Club, and concerts with acts and audiences from around the world are held here regularly. **Below:** View of the Mourne Mountains.

Parks and Gardens

The oldest tree in any arboretum in the whole of Ireland is in Tollymore Forest Park, a spruce dating to around 1750. Close to Newcastle, the park is a delightful place, with forest trails, follies, rope bridges, grottoes, and caves, encased between the sea and the Mournes. Castlewellan Forest Park with its lake and castle lie to the north. There is the Arboretum of Northern Ireland, as well as the beautiful Annesley Garden, which mixes formal and looser designs to wonderful effect, and features fountains, ornamental gates, terraces, and bright, packed borders.

The Murlough National Nature Reserve is a wilder affair. This is Ireland's first nature reserve, a wonderful, precious system of 6,000-year-old sand dunes, lying on a point by Dundrum Bay. Seals swim and wading birds strut the waters around the reserve, and some 22 different species of butterfly, including the Marsh Fritillary, flutter over the dune heath and wildflowers.

Above: Gullion Forest Park – here might be fairies …

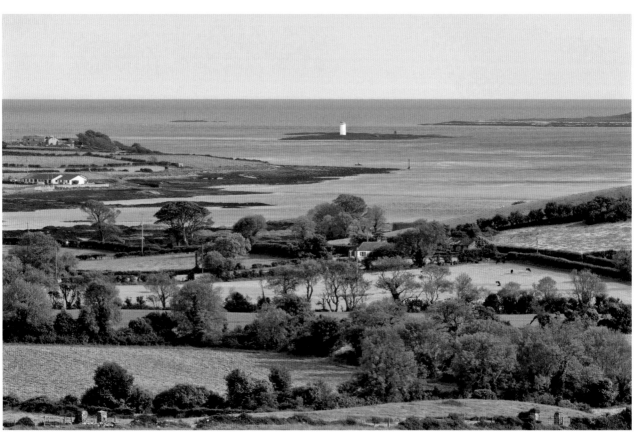

DOWNPATRICK AND NORTH DOWN

This is an area of rich, rolling countryside, with beaches, wetlands, and wildfowl reserves. There are the sophisticated, busy, and playful waters of Strangford Lough. There are the antique shops of Greyabbey, the neoclassicism of Mount Stewart, and the Victorian dignity of Holywood. There are wartime defences and Norman ruins.

Approaching Downpatrick, however, just south of Strangford Lough, one single quality begins to take precedence over all others – a sense of calm and even spirituality. This is St Patrick's Country, and the man and his faith seem to pervade the very stones and soil of the region. His story is told with respectful but objective analysis at the St Patrick Centre in Downpatrick, sited close to Down County Museum, where the Downpatrick High Cross is the central feature of an exhibition on early Christianity. The Centre is in a bowl below Down Cathedral, where, according to tradition, St Patrick's remains are buried, along with the bones of St Brigid and St Colmcille, beneath a slab of granite taken from the Mourne Mountains.

St Patrick in Ireland

The Ards Peninsula shuts like a door on Strangford Lough, but holds ajar between Portaferry and Strangford, and it was through this narrow strait that Patrick sailed in 432.

It was his second time in Ireland. His first sojourn was as a boy, when he was brought from Britain to Ireland as a slave. Tending sheep on Slemish Mountain, he prayed fervently for release until a vision showed him his means of escape.

It was another vision that brought him back to Ireland, one that told him to return to bring the gospel of Christianity to the land. He made his first church in a barn at Saul in County Down; a church still stands there and the locals describe it as a thin place, where earth is close to Heaven. His mission brought him straight to Downpatrick, to the fort on the Hill of Down where the High King of Ireland lived. Patrick converted him to Christianity and then set about moving across the country, preaching God's message. A pattern ensued, whereby he upset local rulers, was imprisoned and then freed by his followers, after which he would build a church and then move on, determined to spread the gospel. Armagh became the centre of his mission, where he established a monastery and a seat of learning. His Confessions are the earliest known writings produced in Ireland, composed to counter rumours from home. His superiors in Britain were displeased with

Opposite top: Strangford Lough, near Greyabbey.
Opposite bottom: Ards Peninsula from Portaferry, County Down.

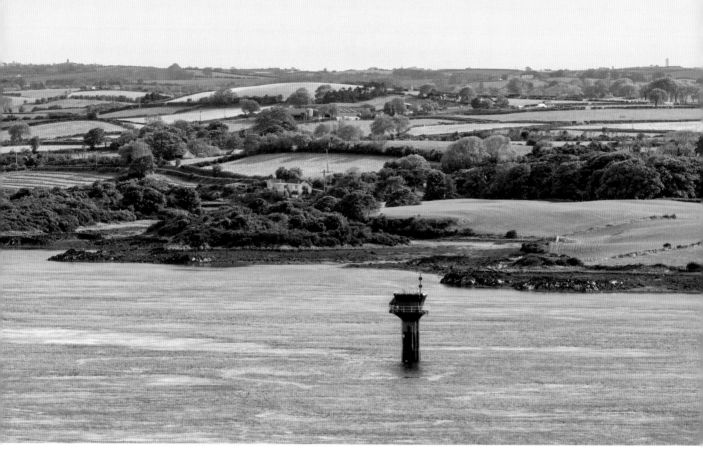

Above: The southern end of Strangford Lough.

him. They had heard he was calling himself Bishop of Ireland, a title no one had granted him, and the money they had expected him to raise was not forthcoming. Worst of all, a companion from adolescence was accusing him of a crime, one that was never specified but was heinous enough to deem him unfit for holy orders.

Whatever his superiors thought of him, Patrick was loved by the people of Ireland, thousands of whom he converted to Christianity. He died where his journey began, at his first church, at Saul, on 17 March, 461.

The Abbeys of North Down

The legacy of monastic life and learning left by Patrick is evident throughout County Down, perhaps most notably in the ruins of the abbeys that were established in the years following the saint's conversion of Ireland's north, and rebuilt and developed by the Norman knight John de Courcy.

Bangor Abbey, on the shoulder of the Ards Peninsula, was founded by St Comgall in 558. By the time of his death, in 601, there were nearly 3,000 monks living there, making it one of the most revered places of learning in Europe. Bangor's North Down Museum has many items dating from the abbey's earliest years. South of Bangor, in Newtownards, is Movilla Abbey, once as important as Bangor, and probably founded by St Finian around the same time.

Holywood Priory Church stands on a site where a monastery was begun by St Laiseran in the early 600s. The ruins of a later abbey are also on the site.

Above: In 1193, John de Courcy's wife, Affreca, founded the abbey at Greyabbey, considered Ulster's finest example of Cistercian architecture from the period. **Below:** Tombstones tell many stories in the graveyard of Greyabbey.

Above: The mountains and the sea, view of Strangford Lough.

St Patrick's Trail

Patrick travelled all over Ulster in his mission to bring Christianity to the north, but it is counties Armagh and Down with which he is most closely associated, and it is to these places that visitors come to learn of his life in Ireland, and to draw inspiration from his teachings and from a closeness to the land he loved.

The St Patrick's Trail has been established to allow curious tourists and committed pilgrims follow in his footsteps. There are, in fact, two trails. One is a walking route – the St Patrick's Way Pilgrim Walk – an 82-mile/130-kilometre journey that starts in Armagh, at Navan Fort, and ends at the saint's grave, in the grounds of Down Cathedral. The course takes pilgrims through Armagh, Banbridge, Newry, Rostrevor, and Newcastle before the final destination is reached. Those making the journey are invited to take with them a pilgrim's passport to be stamped at each given stop, and are presented with a certificate at journey's end.

The second trail is for those travelling by car, and runs between Armagh's Church of Ireland Cathedral and the North Down Museum in Bangor. In between, there are a further 13 recommended stops, all of which add to the story of St Patrick. These include Bagenal's Castle, Saul Church, Bangor Abbey, and Inch Abbey. Founded by John de Courcy, the abbey is where the legend of St Patrick and the snakes was written and stands across the Quoile River from the Mound of Down, a once royal stronghold of the Dal Fiatach dynasty and one of the largest hill forts in western Europe. Struell Wells is another stopping point, where St Patrick is said to have come and bathed while based at Saul.

A number of other sites are suggested on the driving trail, including Slieve Patrick, a mountain close to Saul on the summit of which stands a giant statue of St Patrick, looking out on his country. Pilgrims regularly climb to the peak to pray to the saint.

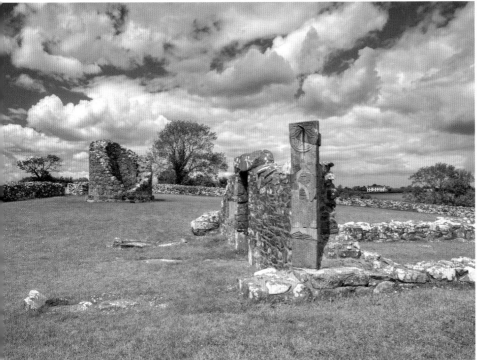

Above: Reagh Island, Strangford Lough, County Down.

Left: The ruins of the monastic site of Nendrum, dating back to the fifth century, are on Mahee Island, in Strangford Lough.

Overleaf: Ballywalter, on the eastern shores of the Ards Peninsula, with the sun setting on the brink of Ireland's beautiful north.

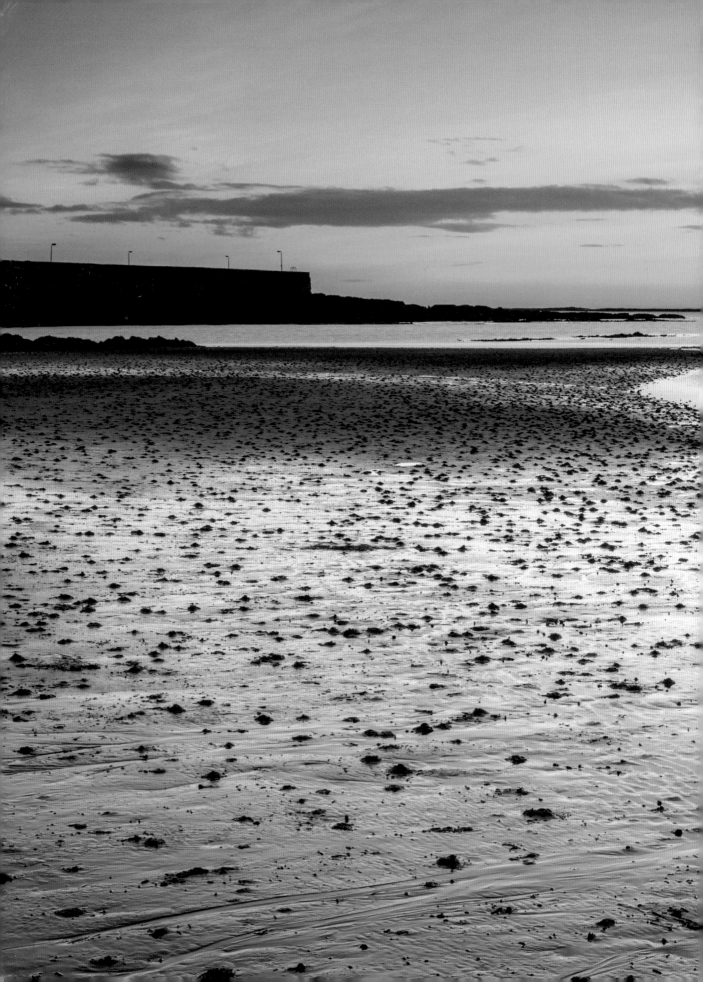

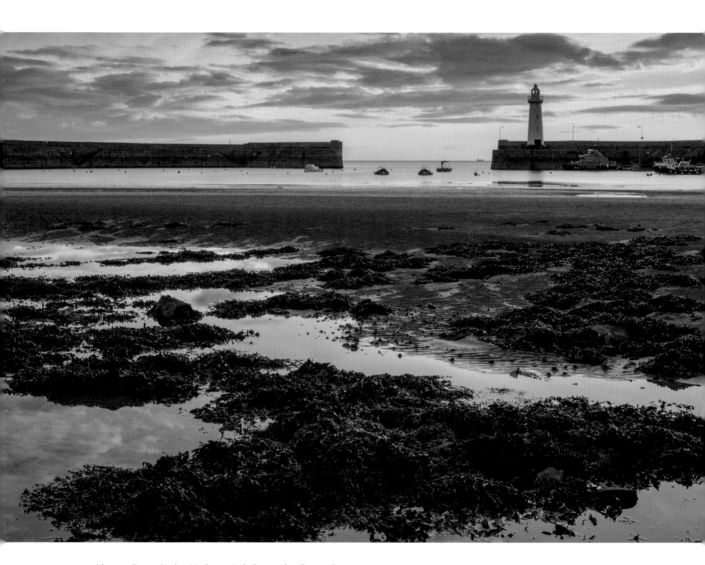

Above: Donaghadee Harbour, Ards Peninsula, County Down.